IMAGES
of America

TRAILSIDE MUSEUM
THE LEGEND OF VIRGINIA MOE

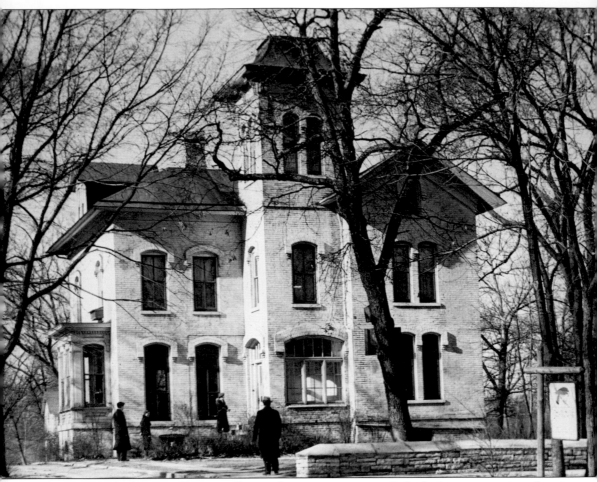

In 1874, Abraham Hoffman, a Chicago businessman, erected the Italianate mansion that is now Trailside Museum. Four years later, the Hoffmans established the River Forest young ladies' seminary for upper-class young women, which later became a boarding school for wayward boys. The second owner of the house was Hugh McFarland, a wealthy carriage maker, who sold the house to the Cook County Forest Preserve in 1919. The Forest Preserve employed Robert H. Ryder, in charge of the Forest Preserve's Thatcher Woods along the Des Plaines River, who occupied the house until 1929. Soon after, the building became the headquarters for the Forest Preserve District of Cook County. (Courtesy of FPDCC 0001 0012 003 UIC Library.)

ON THE COVER: Alfie, the red fox (*Vulpes vulpes*) pictured in 1972 with Virginia Moe, was one of Trailside Museum's education animals. Unable to be released back to the wild, Alfie lived in a large outdoor cage. Since there were no security systems at the time, Alfie slept indoors in the evenings to stay protected from vandals who would try to break into the outdoor cages. (Courtesy of Diane Schulz.)

IMAGES
of America

TRAILSIDE MUSEUM
THE LEGEND OF VIRGINIA MOE

Jane Morocco
Foreword by Paul Harvey Jr.

ARCADIA
PUBLISHING

Published by Arcadia Publishing
Charleston, South Carolina

Printed in the United States of America

Library of Congress Control Number: 2014946836

For all general information, please contact Arcadia Publishing:
Telephone 843-853-2070
Fax 843-853-0044
E-mail sales@arcadiapublishing.com
For customer service and orders:
Toll-Free 1-888-313-2665

Visit us on the Internet at www.arcadiapublishing.com

In memory of Diane Schulz, a good friend and wildlife rehabilitator.

CONTENTS

FOREWORD

Her name was Ginny Moe . . .

Bespectacled, stern-faced, she was curator of Trailside Museum, the local wildlife refuge at the edge of the county forest preserve. The quaint little building built in 1874 had been a private home and even a boarding school once upon a time. But in the 1930s, when Miss Moe moved in, it became the last hope for orphaned or injured forest creatures, the place we children and their parents brought baby squirrels and broken wings and whatever else was helpless or too far from home. And when my pair of tiny pet shop turtles outgrew their plastic bowl with the plastic palm tree, and then even their larger aquarium, Trailside Museum's turtle habitat welcomed them. Part of the three-story house was *exactly* a museum. Taxidermy in dusty glass display cases, the stuffed and posed remnants of woodland residents, stared out at wide-eyed us as we ambled from room to room, faithfully stopping to read every word of the fascinating instructional treatises posted here and there. No local species of mammal, bird, or reptile, or even insect went unrepresented. Then there were the other rooms, all of them on the main floor for convenience sake, where the recuperating or otherwise rehabilitating animals resided amid the cacophony of their conversing voices and the bouquet of their distinctive smells. Those too big to be kept indoors had sheltered, partly enclosed, wire-mesh housing outside. Children of the surrounding community, including yours truly, routinely interned at Trailside, taking turns feeding baby birds with an eye-dropper or cleaning cages and terraria. And at the vortex of it all was Ginny Moe, the local saint whose expression rarely changed and who spoke only when absolutely necessary. But what her demeanor conveyed was in a way the most important lesson anyone ever learned at Trailside Museum: the seriousness of our responsibility to creatures wanting with whom we interact and who, but for us, would surely perish. Ginny Moe is many years gone now. But the neighborhood institution to which she gave all the days of the years of her life, while boasting its ongoing educational value, no longer accepts *living* animals in need. But what good, I wonder, is a place of mere learning if what you learn makes no difference?

—Paul Harvey Jr.
from "A Child Is Reborn"
© 2014 by Paul Harvey Jr.

ACKNOWLEDGMENTS

Without the hard work, support, love, and understanding of my husband, John, this book would never have become a reality. I would like to thank my children, Caitlin, Alex, and Michael, for all your typing, editing, and listening to my Trailside stories all these years. I am forever grateful. My mother prayed the rosary every day for me; thank you Mom! Diane and Pete Schulz sparked the idea for the book on Miss Moe and let me borrow their beautiful photographs. I am so thankful to Paul Harvey Jr. for his wonderful foreword, encouragement, and support. Special thanks to Jim Dooley for sharing the beautiful pastels of Thatcher Woods, painted by his mother, artist Avis Mac, whose early work included portraits of famous actors Jean Harlow, Wallace Beery, and Clara Bow, just to name a few. Ed Lace, retired director of Cook County Forest Preserve District's Little Red School House, shared his wonderful stories of Virginia Moe, who he considered his mentor. I'm grateful to Verna von der Heydt for her kindness in sharing her wonderful husband's stories and images with me. Anne Gallagher and Ed Wasson, for your photographs and stories of Miss Moe, Mary Cooper, and Trailside, you all have made writing this book an incredible journey, one I will never forget.

Additionally, I would like to thank the following people, institutions, and organizations for contributing photographs: Joseph Casale; the Affleck family; Joanne and Joe May; Dawn Waldt; Dan Harper, Roberta Dupuis-Devlin, and Valerie Harris of the University of Illinois at Chicago (UIC) Library Special Collections; Forest Preserve District Cook County (FPDCC); Amber King of the Chicago Academy of Sciences and its Peggy Notebaert Nature Museum, Museum Collections and Archives (CAS/PNNM); Frank Lipo and Beth Loch of the Oak Park and River Forest Historical Society; Dan Haley, editor of the *Wednesday Journal* newspaper; and Ted E. Leverenz. I would also like to sincerely thank the River Forest Library staff, especially Ted Bodewes and Blaise Dierks. Others who provided stories, resources, or encouragement include Scott Neumann, for all of the wonderful work and time you put into this book; John and Mary McCloskey; Jane and John Erickson; Millie Erhardt; Harriet Hausman; John Rigas, past president of the Village of River Forest; Greer Haseman; David Hess of the Gary, Indiana, Library; Serena Sutliff, Duneland Historical Society; Stephen McShane of Indiana University Northwest; J. Ronald Engel; David Bagnall, curator and director of interpretation of the Frank Lloyd Wright Trust; John Roeser; Marsha Thomas of Morgan Park Military Academy; John Archer, president of the Chicago Herpetological Society; Dr. Aaron Vigil of the Visiting Veterinarians; Alex Courtney of the Lincoln Park Zoo; librarian Christine Giannoni and archivist Armand Esai of the Chicago Field Museum; Annette Slovick; Lynn and Tom Zurowski; Paul and Laurie Driscoll; Dan Starr; Marion Baumgardner; and last but not least, Arcadia Publishing's Leigh Scott and Julia Simpson, a wonderful editor.

INTRODUCTION

Things of Nature are not accessories to a child's development, but the very fiber of it—and that the readiest way to a child's heart is through the animal kingdom. Animals teach city bred children lessons their forefathers taught themselves and are invaluable assets in building character and responsibility.

—Virginia Moe, *Gary Post Tribune* interview, 1947

Everyone growing up in the near west suburbs of Chicago, Illinois, which include Maywood, Melrose Park, Forest Park, River Forest, Oak Park, and the Austin neighborhood in Chicago that borders these suburbs, is familiar with the Trailside Museum of Natural History, simply known as Trailside. Since its inception in May 1932, Trailside was the place for children to volunteer or for anyone who had inquires about a wild animal. School groups came from all over the city of Chicago. Boy Scouts earned their merit badges there, and children growing up visiting Trailside brought their children and their grandchildren there. It was the only place where concerned people could bring sick, injured, or displaced wildlife, many of which had injuries or illnesses inflicted by man. The animals, when healed, would be released again. Those that did not heal or could not be released stayed on as education animals. The museum was made up of many long-term residents such as Alfie the red fox, Pooh Bear the raccoon, and John the rabbit, just to name a few.

Trailside would have several curators, but perhaps the most well known and most remembered of all was Virginia Moe, known as "Miss Moe" to everyone who knew her. Speak to anyone in the neighborhood, and they will say they knew her as the old lady who cared for animals who lived above Trailside. But, she was not always old, and she was not the only curator who took care of the animals at Trailside. She was simply the only one who did it for half a century. Miss Moe dedicated her life to the animals in her care and encouraged compassion and all that is good in human nature along the way. Spring through fall, the phone never stopped ringing at Trailside. Miss Moe faithfully answered every call, and whatever animal was determined unable to be put back with its mother or too injured to be left alone, Miss Moe welcomed at Trailside. She was one of those fascinating people who always seemed to know what the animal was ailing from and just what to do.

My personal connection to Miss Moe and Trailside Museum began in the 1950s. Field trips to Thatcher Woods, the pavilion, and Trailside Museum were weekly excursions. In those days, our family of five rode our bicycles from our home in Chicago's Austin neighborhood over five miles to Trailside. Most of the time, half the neighborhood kids came along, and even a few Catholic priests who were friends of my parents made the ride.

My mother was a field biologist, and she became friends with Miss Moe on our weekly trips to Trailside. With my mother's biology background, we tended to have some of the same animals and insects that Trailside kept, so I felt quite at home at Trailside. I cannot tell you how many times my sister, who was not quite the animal lover I was, would walk into my bedroom and exclaim,

"Your room smells just like Trailside!" My retort was usually along the lines of "well of course, animals have an odor. You can walk into the reptile house at the local zoo anytime of the year and there is an odor."

Volunteering as a junior assistant at Trailside just seemed like the natural thing for me to do. So when I was old enough to make the trip alone from my neighborhood to Trailside, that is exactly what I did. After grade school, I would go every summer day and weekends during high school. In college, I would come home and head right over to Trailside. It was not work to me. I volunteered at Trailside for 10 years, and I can still remember my very first day. At 8:00 a.m., I timidly walked into one of the rooms known as the Bird Room. There had to be 15 children, all my age, shoulder to shoulder, cleaning and sifting sand out of the cages. I tried to squeeze my way in to start cleaning but there were so many kids, and no one was moving for me. Miss Moe must have been watching from the back of the room, unbeknownst to me, and mildly asked them to "Let Jane in." By the end of that summer, most of the children had gone back to school. I did too, but still made time to come back every weekend. She was so interesting. She had a card file box with our names and phone numbers, along with our zodiac signs. She said she had ESP (extrasensory perception), and I was always careful about my thoughts around her.

As I look back as an adult now, I realize what an extraordinary impact Miss Moe had on our community. Yes, it was wonderful for all the wild animals she doctored and sheltered and released back into the wild, but it was also about helping people. We all learned compassion and valuable lessons with each animal brought into Trailside. What prompted someone to bring this injured animal to Trailside in the first place? What caused this animal to be injured? Was there something we could have done to prevent it? How could we make the environment a safer, better place for both animals and humans to coexist? Miss Moe welcomed children to volunteer at Trailside because she knew that making our environment and our planet a better place to live was going to start with young people. She helped people who cared about our wildlife by giving them a place to bring an animal that needed our care. It was during these moments when I would ask myself those questions. I believe Virginia Moe, in her compassion for all living creatures, inspired compassion in humans. In healing the wild creatures we share our daily lives with, we are healed.

For 52 years, Miss Moe dedicated her life to Trailside and our community until her death in 1991 at the age of 83. For years I have been driving past Trailside and remembering my days there so many years ago, still feeling like it was yesterday. When the opportunity came up to write this book, I was very excited. After all, 50 years of my life have been connected in one way or another to Trailside, Miss Moe, and the local community to which Trailside belongs.

Virginia Moe grew up in Gary, Indiana, and spent many of her summer vacations at her family's cottage in Miller Beach. Later they enjoyed a summer home named Valhalla in the Indiana Dunes State Park from 1927 to 1937. Her father was Ingwald Moe, a contractor responsible for building many of Gary's largest public buildings, including city hall. Along with her mother, Louisa, a brother, and sister, the family took an active part in the movement to establish a national park in northwestern Indiana. Nature lovers, they also were members of the committee that obtained the land that became the state park. Her grade school principal, Catherine Johns, remembered her as a born naturalist and a brilliant student. When Virginia Moe finished high school, she became a militant defender of the Dunes. She became a writer for the *Gary Post Tribune* and wrote many stories and articles on the Dunes. Charles "Cap" Sauers, the founder of Trailside and superintendent of the Forest Preserve District of Cook County from 1929 until 1964, recognized Virginia Moe's talents and hired her in 1939 to be the assistant curator of Trailside Museum. Moe replaced Bertrand Wright, a herpetologist who lived at 710 Forest Avenue in River Forest, Illinois. Wright left Trailside to pursue other interests.

Sauers knew Virginia Moe's father and mother when he was assistant director of conservation for the state of Indiana from 1919 to 1929. When curator of Trailside Gordon Pearsall left his position in early 1940s, Moe took over as director. In 1946, she wrote *Animal Inn*, a children's book about the animals of Trailside Museum. The sketch illustrations were wonderfully done by Milo Winter. *Animal Inn* was published by Houghton Mifflin, accepted by the Literary Guild,

and carried by the American Library Association. Moe was also a writer for the nature series *Childcraft Encyclopedias* while she worked at Trailside.

For seven decades, Virginia Moe worked and lived at Trailside Museum, giving all of herself to the woods, the animals, teaching children to love nature, and dedicating herself to the community. On May 12, 1989, the Forest Preserve District of Cook County decided to close down Trailside Museum. Their decision was based on the US Department of Agriculture (USDA) citing the museum for noncompliance of federal codes. The USDA stated repeatedly their intent was not to close Trailside, and the required improvements need not be costly. Rather than fix the issues, the Forest Preserve followed through on their decision to close the museum doors. As the people of Cook County found out about the Forest Preserve's intent, a grassroots "Movement to Save Trailside" was formed. After numerous protests, thousands of signatures to save Trailside, local and national news coverage, and the support of several commentaries on Paul Harvey's national radio broadcasts, not only was Trailside saved, but a $500,000 addition was added to the museum specifically for wildlife rehabilitation and education. Virginia Moe, now in her 80s, was happy that her beloved museum was saved. In 1991, Virginia Moe died. She had requested her ashes be spread in the pond behind Trailside.

Soon after her death, Trailside Museum was named after a Cook County commissioner, and in 2006, Cook County president John Stroger Sr., facing a $300 million budget deficit, decided that wildlife rehabilitation was too costly and cut the program from the Forest Preserve budget. Today, Trailside no longer treats sick, injured, or displaced animals.

Through images and captions throughout this book, you will take a journey of the beginnings of Trailside Museum, Thatcher Woods, and the area around the River Forest community. You will meet the various people and animals that are a vital part of Trailside's history. Much of the information on the curators came from personal journals, memoirs, and oral histories taken from people who knew them well.

One

THE EARLY YEARS

The Forest Preserve District was created through the popular vote of the citizens of Cook County, Illinois, during an election held on November 6, 1914, and was formally organized February 11, 1915. An advisory committee was created, and by 1917, it had acquired 21,500 acres. Thatcher Woods in River Forest, Illinois, the current home of Trailside Museum, which nestled on the Des Plaines River, was included in this early acquisition. (Courtesy of FPDCC 00 004 0001 039 UIC Library.)

This undated postcard is titled "Branch of Des Plaines River Near Oak Park, Ill." River Forest did not have its own post office until a branch office was established on March 1, 1927. All mail went through Oak Park's post office, thus the title "near Oak Park." (Courtesy of Joe and Joanne May.)

Sentiments on this postcard dated August 27, with no year, read, "Say best wishes and a happy New Year." In the early 1900s, postcards were used as a quick form of mail rather than a message sent from a vacation destination. The title on this one reads "Des Plaines River, River Forest, Illinois." The river, which flows through the western suburbs, bordering River Forest on the west, and located near Trailside Museum, has had several different names. Early French explorers called it Riviers Aux Plaines. Today it is known as the Des Plaines River. (Courtesy of Joe and Joanne May.)

This unused, undated postcard image of the Des Plaines River north of Trailside Museum captures its loveliness. The beauty of the river was a focal point in the original discussions for a park and preserve system. Two environmentalists, Jens Jenson and Dwight Perkins, imagined a system of boulevards connecting open spaces with commercial and residential areas. (Courtesy of Joe and Joanne May.)

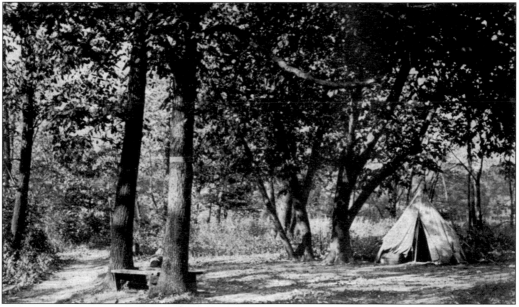

This postcard dated August 4, 1919, features a "View along the Des Plaines River," near Oak Park. During the early 1900s, people lived on forest preserve property. With their tent pitched, this family enjoys a day along the river. Jens Jenson, who was also a landscape architect, once described the beauty of the Des Plaines: "The master's hand had created a landscape worthy of man's love and affection for his own good." (Courtesy of Joe and Joanne May.)

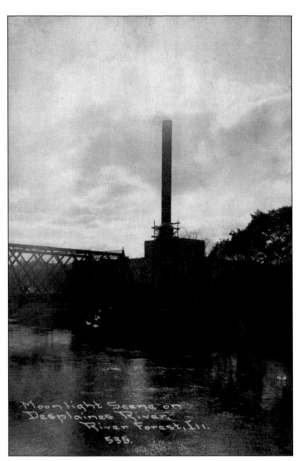

This August 16, 1915, postcard is titled "Moonlight Scene on Des Plaines River, River Forest, Ill." This is the Lake Street train bridge just south of Trailside Museum. The Maywood Public Service tank is the structure in the background. In 1932, the first curator of Trailside Museum, Mary Cooper, located some dead birds, towhees, behind the tank that had been hunted and killed by a saw whet owl. (Courtesy Joe and Joanne May.)

The Madison Street Bridge, near Maywood, shown on this postcard dated September 11, 1911, stretches across the Des Plaines River, bordering Thatcher Woods. Just south of this bridge is Forest Home Cemetery. Many people of interest are buried there along the Des Plaines River. Ernest Lehmann, who established the Chicago Department store called The Fair, is buried there. Legend has it he drove a pleasure boat drawn by geese down the Des Plaines River. (Courtesy of Joe and Joanne May.)

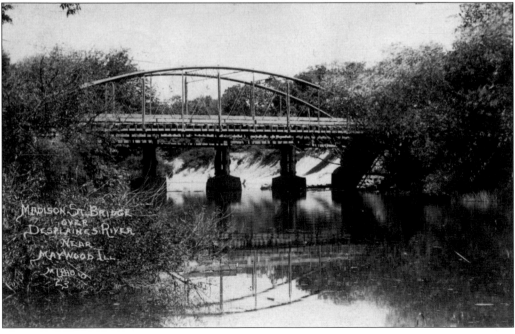

Thatcher Woods and the Des Plaines River, just north of Trailside, was the area where Ernest Hemingway spent most of his days as a member of the Agassiz Club. While still in kindergarten, he joined a local branch of the club, which was organized by his father. The group met Saturday mornings in Thatcher Woods, gathered rock and insect specimens, and identified birds. (Courtesy of Joe and Joanne May.)

This postcard dated October 5, 1905, titled "The River Road Near Oak Park, Ill.," depicts another lovely Des Plaines River scene. This postcard had a long letter attached to it, indicating that in the early 1900s, postcards were used for writing correspondence more often than actual letters. (Courtesy of Joanne and Joe May.)

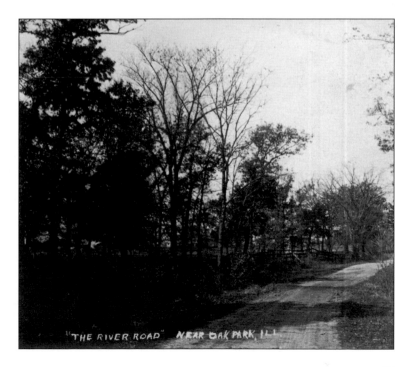

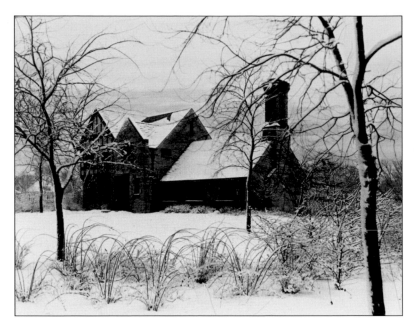

The Cook County Forest Preserve District built a two-story, English-style brick and stone structure in 1931 to house its new general headquarters. The structure was built on land now known as Cummings Square, a nine-acre tract of wooded land located at Harlem Avenue and Lake Street in River Forest. (Courtesy of FPDCC 0001 0013 021 UIC Library.)

The cost to build the new headquarters was $50,000, and the building would house the executive offices, landscape architects, and the engineering and drafting departments. New trees and plants were added to landscape the new office, making it look as beautiful as the other River Forest homes in the neighborhood, rather than an office building. (Courtesy of FPDCC 00 06 0002 0009 029 UIC Library.)

Alfred Bailey was the first person Cook County Forest Preserve general superintendent Charles Sauers wrote to with his idea to open a nature museum in Thatcher Woods. Before moving to Chicago, Bailey worked for the Louisiana State Museum for three years and was curator for a museum in Colorado. After traveling the country on expeditions, Bailey accepted the director position at the Chicago Academy of Sciences in 1927. This relationship between Sauers and Bailey became the genesis of what was to become Trailside Museum. (Courtesy of CAS/PNNM.)

ALFRED M. BAILEY
Director The Chicago Academy of Sciences

NOTED
NATURALIST
TRAVELER
and
PHOTOGRAPHER

♦

Fascinating Talks About
Birds
and Other Creatures
of the Wild

Illustrated With
Wonderful Motion Pictures

REDPATH

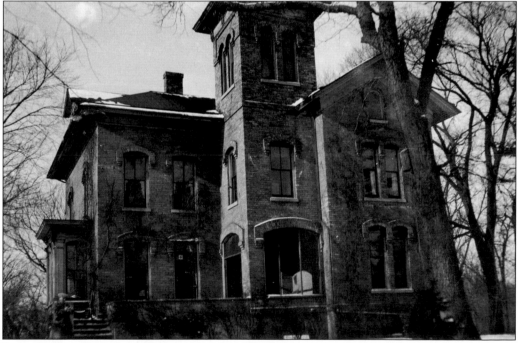

In establishing Trailside Museum in Thatcher Woods, letters from Bailey to Sauers in 1930 indicate the general plan for Trailside was based on the Trailside Museum at Bear Mountain, New York. The purpose of this museum was to educate the public in conservation of all wildlife and to have on exhibit, either living or mounted, species found in the region. Once the Forest Preserve District moved its headquarters to its new building, plans were underway for the opening of Trailside Museum of Natural History in 1932. (Courtesy of FPDCC 00 06 0006 0315 UIC Library.)

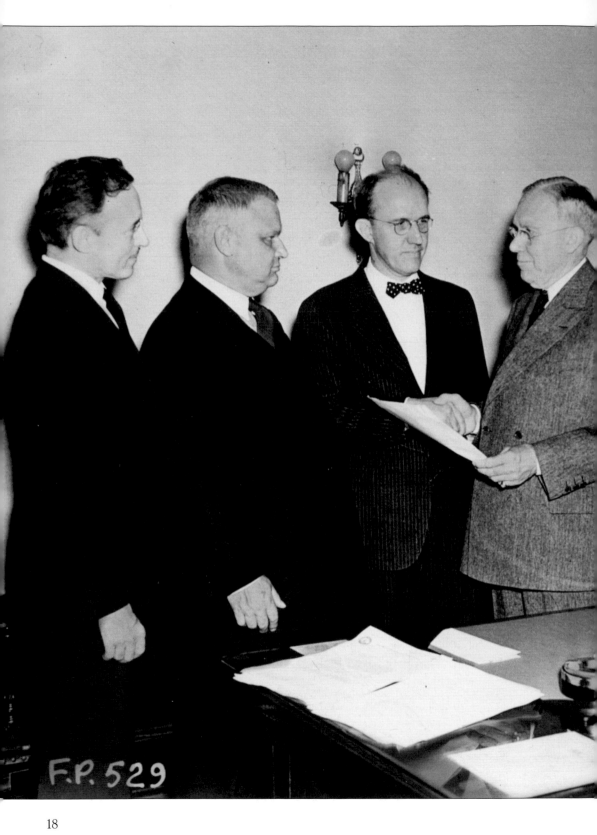

F.P. 529

Cook County Forest Preserve general superintendent Charles "Cap" Sauers, in the bow tie, is seen shaking hands with Cook County board president Clayton Smith in this 1932 photograph. Sauers was appointed to his position on May 15, 1929, when he replaced M. S. Szymczak. Szymczak resigned effective December 3, 1928, after being elected clerk of the Superior Court. In his absence, John Berry served as acting superintendent until Sauers's appointment. Before taking his position with Cook County, Sauers served as assistant to Richard Liebner, the director and superintendent of lands and waters with the Indiana Department of Conservation. This was the beginning of the state park initiative in Indiana. A graduate of Purdue University, he received his bachelors of science in agriculture. Sauers served in the military as captain of field artillery from 1917 to 1919, earning the nickname "Cap." He was a member of the board of directors of the National Conference on State Parks and the American Institutes of Park executives for various terms. In 1930, he received the Pugsley Bronze Medal from the American Scenic and Historic Preservation Society. (Courtesy of FPDCC 00 01 0005 026 UIC Library.)

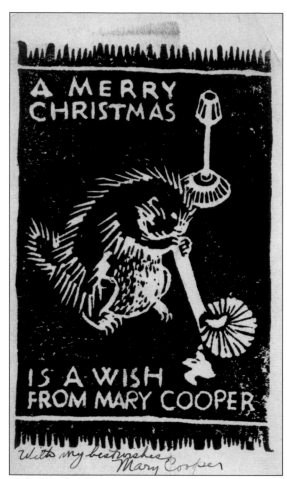

"A Merry Christmas is a wish from Mary Cooper" is shown here, with a porcupine illustration drawn by Mary herself in 1931. The postcard was addressed to Alfred Bailey, the director of the Chicago Academy of Sciences. Mary Cooper was promised the curator job at Trailside, but deep into the Depression of the 1930s, the job fell through. She took a camp job out east and had a terrible time with porcupines invading her campsite and keeping her up at night. The curator position at Trailside later came through for Cooper, and even after the unpleasant experiences she had that summer with porcupines, she still welcomed them to Trailside if they were sick or injured. One, Pricky, became quite a pet. He was brought to the museum as a baby and after a while he got too big for her to carry around. She described his temper as surly and said he was getting to be more like a regular porcupine all the time. (Courtesy of CAS/PNNM.)

Ansell Hall, a park naturalist, actually started the very first Trailside Museum in 1921, although it did not go by that name. Hall was the first to establish innovative and interpretive programs and founded the Yosemite Museum Association. In 1923, the Association of Museums became interested. Herman Carey Bumpus took over the program and became known as the "Father of Trailside Museums." The famous Bear Mountain Trailside in New York was established in 1927, with William Carr as the first director. (Courtesy of FPDCC 01 05 0041 0455 058 UIC Library.)

Cook County board president Clayton Smith (second from the right) poses for this photograph with some of the Cook County commissioners. To the left of President Smith is William Erickson, and at far left is Edward Sneed. Smith was instrumental in the initial development of Trailside Museum. (Courtesy of FPDCC 00 01 0005 017 UIC Library.)

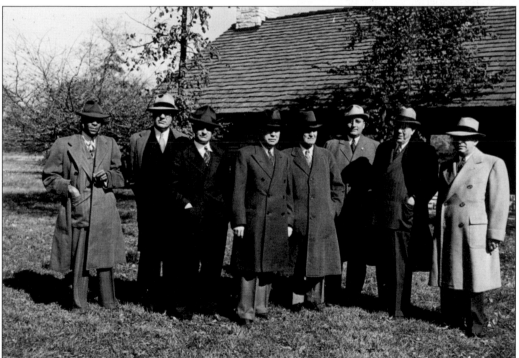

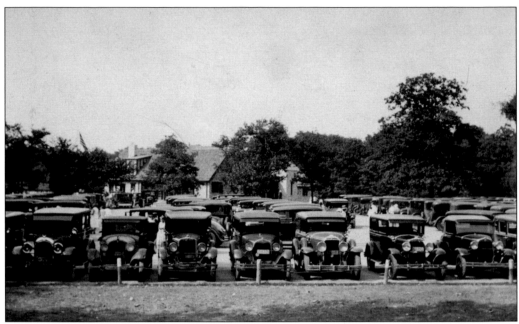

Thatcher Woods Pavilion and the overflow parking lot just to the south of the pavilion are packed with cars. With a little imagination, there was plenty to do. There were bridle trails, hiking and bicycle trails, and picnic areas. There were also three baseball diamonds, a large dance floor and shelter, and half a dozen smaller open-air dance floors. This particular area could accommodate 100,000 people on any given day. Prior to 1929, this area was known mainly as a picnic area. Since the hiring of Superintendent Sauers, work on the original plans for the Thatcher Woods area was advanced nearly a decade. Extensive landscaping was done, and the old, dead, and diseased trees were removed and replaced with newly planted trees and shrubs. (Above, courtesy of FPDCC 00 06 0004 0018 073 UIC Library; below, courtesy of FPDCC 00 06 0004 0018 076 UIC Library.)

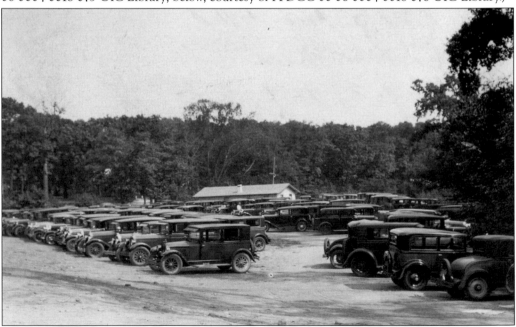

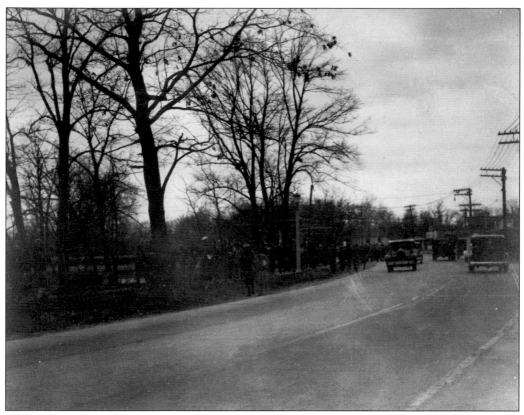

The hikers in this 1930s photograph are hard to identify as they hike east on the south side of North Avenue (Route 64) in River Forest. Thatcher Woods encompasses the area from North Avenue south to Madison Street. The woods are comprised of prairie, flood plain, forest, and savannah. (Courtesy of FPDCC 00 06 0001 0002 051 UIC Library.)

The Grand Army of the Republic memorial plaque was dedicated in 1930 after the land was acquired by the Forest Preserve District in 1917. It is a memorial to the Grand Army of the Republic, the largest Civil War veterans organization. This plaque is located on the northwest corner of Thatcher and Washington Streets in South River Forest, which is also part of Thatcher Woods. (Courtesy of FPDCC 0001 0012 001 UIC Library.)

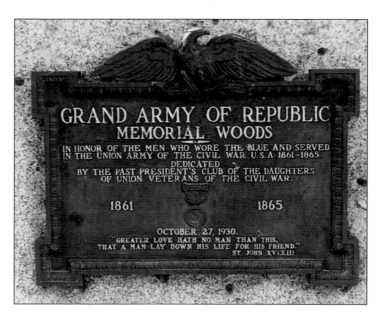

GRAND ARMY OF REPUBLIC MEMORIAL WOODS

IN HONOR OF THE MEN WHO WORE THE BLUE AND SERVED
IN THE UNION ARMY OF THE CIVIL WAR U.S.A 1861–1865
DEDICATED
BY THE PAST PRESIDENT'S CLUB OF THE DAUGHTERS
OF UNION VETERANS OF THE CIVIL WAR.

1861 1865

OCTOBER 27, 1930.
"GREATER LOVE HATH NO MAN THAN THIS,
THAT A MAN LAY DOWN HIS LIFE FOR HIS FRIEND."
ST. JOHN XV: XIII

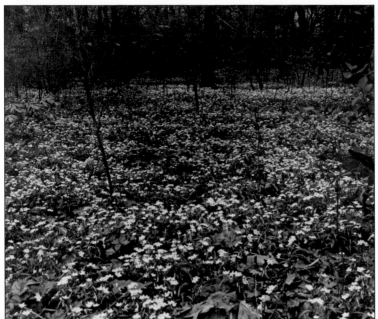

In 1932, Mary Cooper wrote in her diary that she could not believe that she actually got paid for working at the Forest Preserve District. She loved taking walks in Thatcher Woods to see all the wildflowers coming up. She observed a wide variety around the museum, including hepaticas, pepper root, Dutchman's breeches, bloodroot, and spring beauties. (Courtesy of FPDCC 00 09 0001 0000 004 UIC Library.)

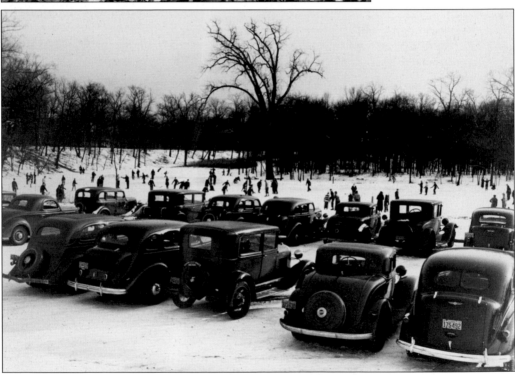

Thatcher Glen Pond and parking lot is located directly behind the Trailside Museum in Thatcher Woods. In this 1930s photograph, numerous skaters glide across the man-made pond. A few years later, a warming house was added for skaters to keep warm while they put their skates on. Strangely enough, with the exception of Wolf Lake, according to the Forest Preserve's Roberts Mann, there were no natural lakes on Forest Preserve property, only man-made lakes, ponds, or sloughs. (Courtesy of FPDCC 00 01 0007 002 UIC Library.)

A view of the skaters on the pond behind Trailside Museum in this undated image shows figure skaters as well as boys playing hockey. Ice-skating was a popular form of recreation in the forest preserves for local youth looking to enjoy nature and have fun at the same time. (Courtesy of FPDCC 00 06 0006 0244 UIC Library.)

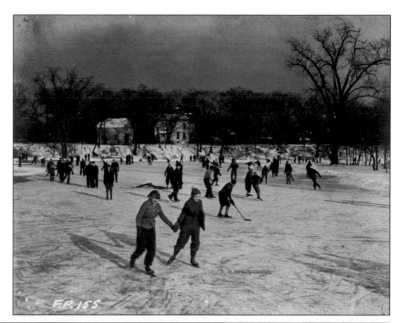

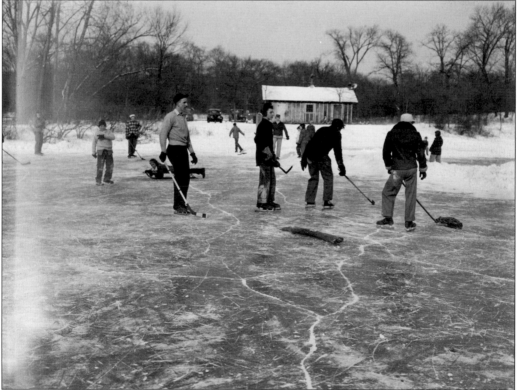

Young men play a game of hockey on the pond, also called the slough, located in Thatcher Glen. The pond can be seen from Trailside. This 1937 image shows the old warming house, which had a stove to warm cold hands and toes after an afternoon of skating. The warming house was eventually torn down. The pond was created by damming the old channel and oxbow of the Des Plaines River. (Courtesy of FPDCC 00 06 0006 0281 UIC Library.)

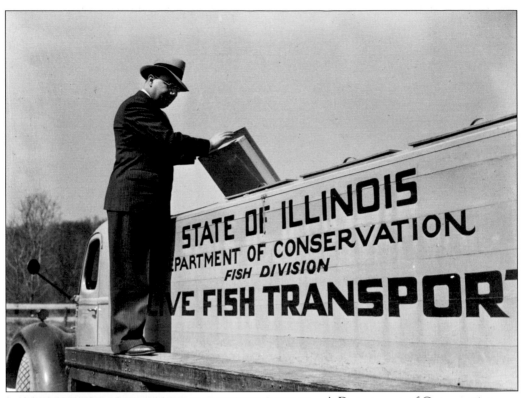

A Department of Conservation official checks a live fish transport truck in the 1930s. The Department of Conservation and the Forest Preserve District's Fisheries Department work in cooperation to stock a number of the district's lakes, ponds, and streams twice a year, including the pond behind Trailside and the Des Plaines River. (Courtesy of FPDCC 00 06 0006 0309 UIC Library.)

A Department of Conservation employee strikes a pose in the 1930s in front of one of the district's buildings, part of the Cook County Forest Preserve District. The Forest Preserve, which includes Trailside Museum and Thatcher Woods, is one of the nation's oldest and largest preserve systems. (Courtesy of FPDCC 00 06 0013 1762 UIC Library.)

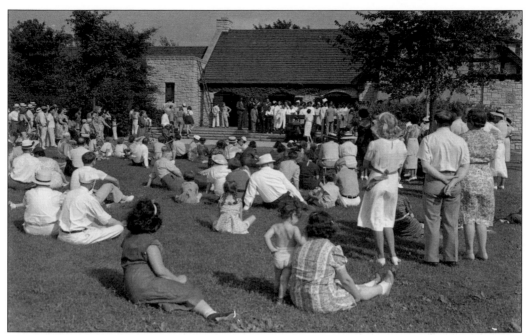

Families enjoyed free concerts in the summer at the Thatcher Woods Pavilion, shown here in the early 1930s. With money being tight for many families, the Forest Preserves were an enjoyable way to spend an afternoon free of charge. The pavilion had two fireplaces, washrooms, and a concession stand. (Courtesy of FPDCC 00 06 0006 0129 UIC Library.)

A group of singers happily rehearse a number on the stairs of the Thatcher Woods Pavilion. In the 1930s, the pavilion was the place for concerts, plays, meetings, and all kinds of organizations to meet and perform. Centrally located in Thatcher Woods, it was easy to get to by bicycle, car, or foot. (Courtesy of FPDCC 00 06 0006 0166 UIC Library.)

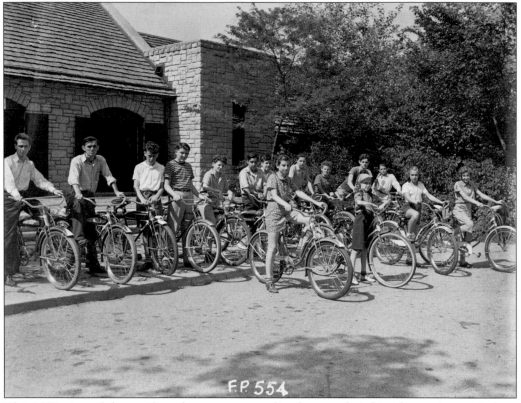

This 1937 view of the pavilion shows youngsters lined up on their bicycles getting ready for a group ride through the winding roads and old forests known as Thatcher Woods. The group would undoubtedly make a stop to see the wildlife at Trailside Museum to the south of the pavilion. (Courtesy of FPDCC 00 06 0006 0295 UIC Library.)

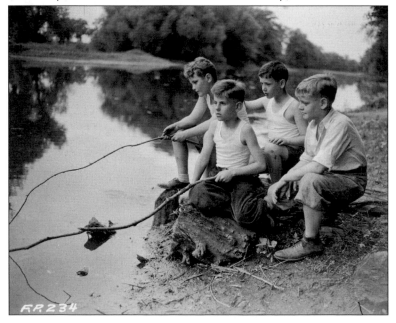

Fishing on the Des Plaines River was a favorite pastime for young boys lucky enough to live in the neighborhood near Trailside Museum. In the 1930s, it was common for young boys to make their own fishing poles from long sticks they found on their way to the river. (Courtesy of FPDCC 00 06 0006 0327 UIC Library.)

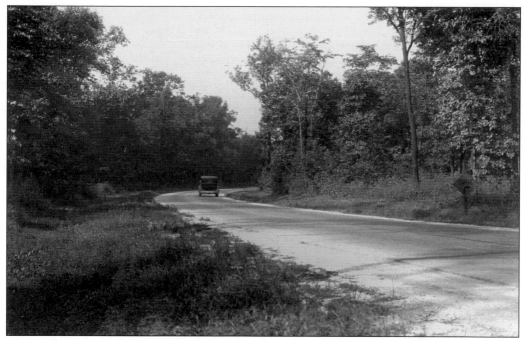

Just north of Trailside Museum, a driver takes a winding road through Thatcher Woods that will lead to the pavilion, a beautiful stone shelter. The winding road most likely was built in the early 1930s by the Civilian Conservation Corps (CCC). The CCC did double duty by providing employment and protecting the nation's natural resources. (Courtesy of FPDCC 00 06 0007 0000 299 UIC Library.)

The development scheme for Thatcher Woods is shown in this undated map. General superintendent Charles Sauers was credited with doing a splendid job with the Forest Preserve since he took the job in 1929. It was said that he moved everything along so quickly that the district was years ahead of the original schedule of new developments. (Courtesy of FPDCC 0001 0013 022 UIC Library.)

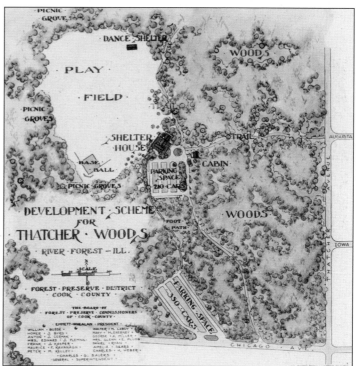

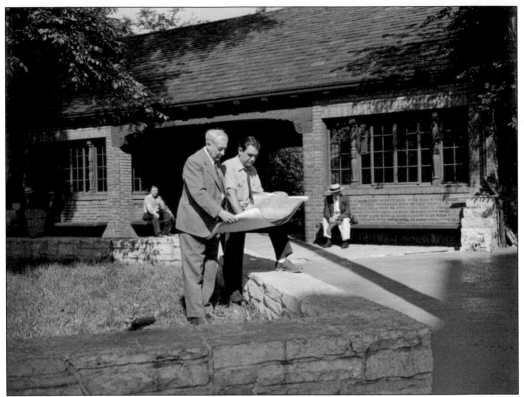

Two officials look over blueprints at the corner of Harlem Avenue and Lake Street in River Forest. This small, 1930s Tudor revival–style shelter house featured two waiting rooms and replaced a Frank Lloyd Wright–designed real estate office. Past the shelter area, park-like paths led to the band shell stage, also the headquarters of the Cook County Forest Preserve District. (Courtesy of FPDCC 00 06 0008 1751 UIC Library.)

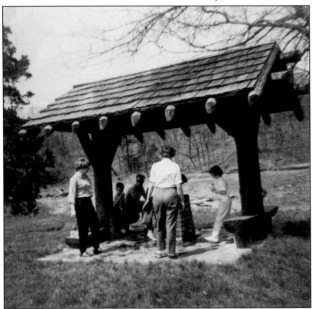

In 1931, the trailside shelters were proposed by Charles Sauers to accommodate people in the forest preserves during inclement weather, and $25,000 was put aside for this project. Frances Dickenson, president of the Chicago Academy of Sciences, suggested to Superintendent Sauers that perhaps they could be designed in such a way that they could be adapted to museum use later on. (Courtesy of Monica Affleck.)

Two

TRAILSIDE MUSEUM

Eight-year-old Anne Wasson holds a bull snake (*Pituophis catenifer sayi*) while another girl looks on with trepidation in this 1937 photograph taken at Trailside Museum. Anne would volunteer every day after school when Mary Cooper was curator and also when Virginia Moe took over the position. Anne first visited Trailside with her mother, Isabel Wasson, a geologist and ornithologist who organized a group called "Friends of Trailside," which met at Trailside weekly. The Wasson family would later visit Mary in Wyoming. One visit to Wyoming culminated with a six-day horse-packing trip. The Wassons, who were professional geologists, taught Mary about the ancient past of the world around her. (Courtesy of Anne Gallagher.)

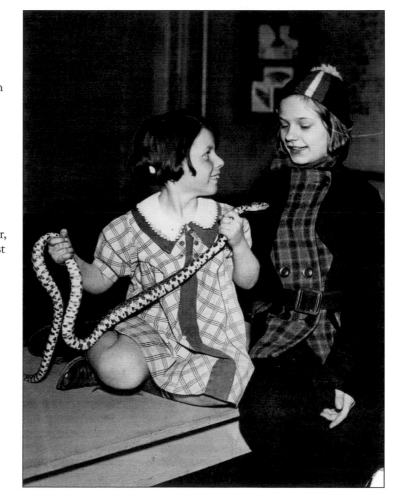

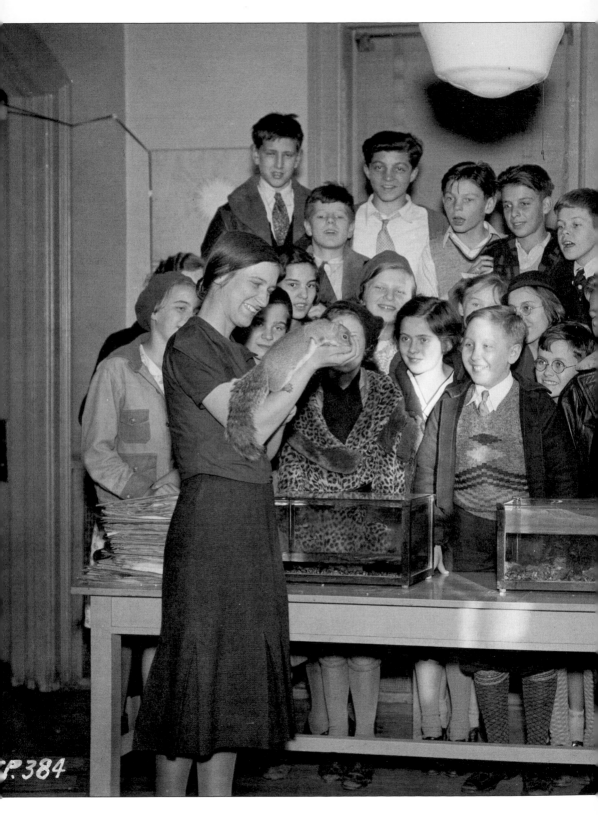

Look at the amazement on these young peoples' faces as new curator Mary Cooper gives a lecture about squirrels. In 1932, Cooper accepted the position at Trailside after working for the Chicago Academy of Sciences as a taxidermist. Before coming to Trailside, she majored in ancient languages at Berea College and studied art at the Art Institute of Chicago. While at the art institute, she lived at her parents' residence in Maywood, Illinois, and would take the L (elevated train) to school. During that time, Cooper worked as an intern at the Chicago Field Museum of Natural History. At the time, she wanted to be an animal illustrator. (Courtesy of FPDCC 00 06 0006 0000 004 UIC Library.)

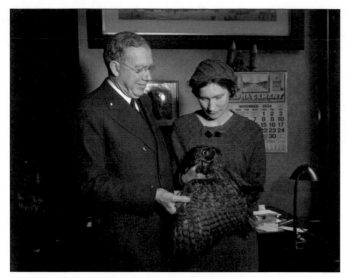

On January 11, 1935, this photograph appeared on the cover of volume three of the *River Forest Optimist*, delivered to residents every Friday morning. Clayton Smith, president of the board of Forest Preserve Commissioners, is seen examining the wing of a great horned owl (*Bubo virginianus*) in the hands of Mary Cooper, the curator of Trailside, where the owl was one of the many attractions. (Courtesy of FPDCC 00 06 0001 001B 005 UIC Library.)

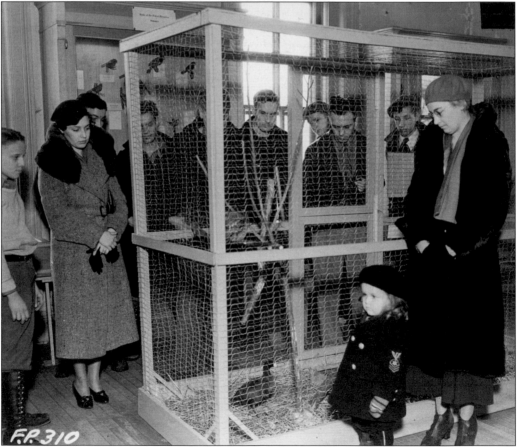

A curious group of visitors look into the cage of a coot in the newly opened Trailside Museum in 1932. Many of the cages were made by a carpenter at the museum. This coot is a member of the rail family (*Rallidae*). The greatest species variety occurs in South America, but the birds are also common in Europe and North America. (Courtesy of FPDCC 0001 0012 007 UIC Library.)

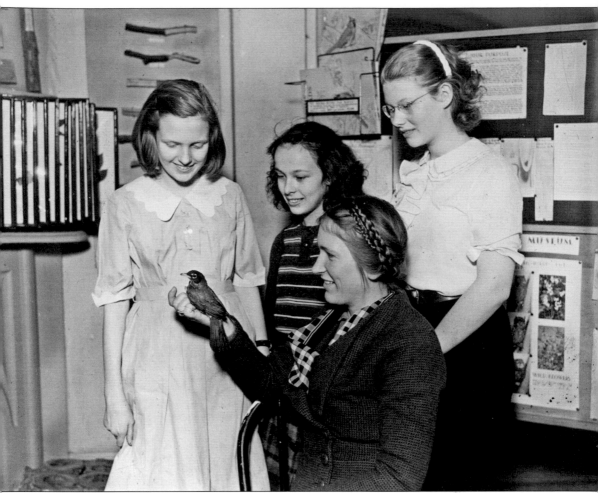

Three Oak Park schoolgirls, from left to right, Barbara Hulbut, Jacqueline Bond, and Milicent Hulbut, listen as curator Mary Cooper explains the natural history of the American robin (*Turdus migratorius*) she is holding in this image from March 14, 1935. Even though Mary Cooper was married to artist Joe Back, she still went by the name of Miss Cooper while working at Trailside. While working there, she made $100 per month. While this did not seem like a lot of money at the time, Cooper felt the job gave her the experience she was seeking. One morning, she received a call from Superintendent Sauers offering her husband, Joe, a position as a foreman overseeing a group of 50 workers who were part of the thousand-man crew known as Roosevelt's Conservation Army. The job came with a salary of $175 per month. (Courtesy of FPDCC 00 01 0012 032 UIC Library.)

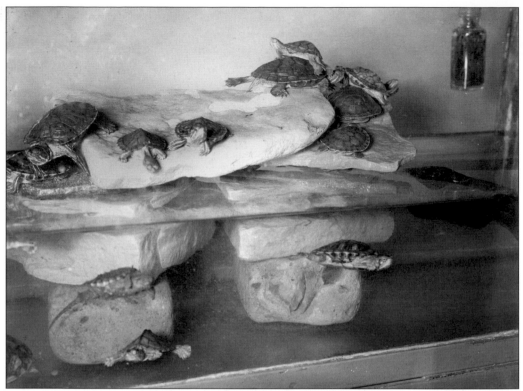

A large tank displaying a variety of turtles is shown in this early 1940s image. It was originally suggested by the Chicago Academy of Sciences to Superintendent Sauers that a special outdoor exhibit be built for turtles. Due to a lack of funds at the Forest Preserve District, many of the outdoor exhibits did not get built. (Courtesy of FPDCC 0005 0002 0000 310 UIC Library.)

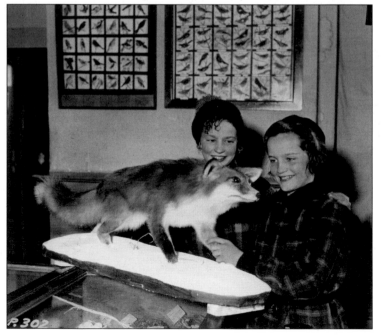

Two young girls excitedly observe one of several mounted exhibits at Trailside. In 1932, many of the mounted exhibits were donated by the Chicago Academy of Sciences and the Massachusetts Audubon Society at 66 Newberry Street in Boston. Other mounts were created by curator Mary Cooper. (Courtesy of FPDCC 00 01 0011 037 UIC Library.)

Young girls admire butterfly mounts in the 1930s. At the suggestion of the Chicago Academy of Sciences, many of the displays were either on loan or purchased from the General Biological Supply House, located at 761 East Sixty-ninth Place in Chicago. (Courtesy of FPDCC 00 01 0012 004 UIC Library.)

A young student looks through one of several microscopes that were available to the public at Trailside. The Chicago Academy of Sciences helped stock Trailside in the early years with materials. Equipment was bought at wholesale price, given out on loan, or donated by the academy if they had extra materials they were not using. (Courtesy of FPDCC 00 06 0006 0000 003 UIC Library.)

Every spring, Trailside received hundreds of eastern cottontail rabbits (*Sylvilagus floridanus*). Heavy spring rains would wash away nests, or lawnmowers would destroy them. Often, would-be good samaritans picked up nests because they did not see a mother. What they did not know was that mother cottontails watched over their babies from a distance to hide the nest location from predators. In this 1940s photograph, cottontail babies are enjoying their lettuce. (Courtesy of Diane Schulz.)

Due to the large number of children wanting to spend time at Trailside, curator Mary Cooper started a junior assistant program. Children aged 12–18 cleaned and fed the animals and made enthusiastic tour guides. This undated image of James von der Heydt's certificate shows the signatures of the general superintendent of the Forest Preserve, the Chicago Academy of Sciences director, and Mary Cooper. (Courtesy of Verna von der Heydt.)

Trailside Museum Junior Assistant Certificate

COMMISSIONERS

Emmett Whealan
President
William Bush
Homer J. Byrd
Mrs. Edward J. Fleming
Frank J. Kasper
Maurice F. Kavanagh
Peter M. Kelly
Walter J. LaBuy
Mary McEnerney
George A. Miller
Mrs. Glenn E. Plumb
Daniel Ryan
Amelia Sears
Charles H. Weber

FOREST PRESERVE DISTRICT
of COOK COUNTY
ILLINOIS

Charles G. Sauers, General Superintendent

GENERAL HEADQUARTERS
Cummings Square
River Forest,
Illinois
TELEPHONES
Columbus 8400·Forest 4470

REAL ESTATE AND
LEGAL DEPARTMENTS
547 County Building
Chicago,
Illinois
TELEPHONE
Franklin 3000

JAMES VON DER HEYDT

The Forest Preserve District of Cook County and the Chicago Academy of Sciences are glad to recognize the value of your services to Trailside Museum. Generously and without thought of reward, because of your interest in the Museum and your enthusiasm for it, you have given much time and effort to its business over a period of many weeks, assisting in its activities and supporting its policies.

For this reason, and because of the assurance that formal acknowledgement of it will make you yet more useful to the Museum in the future, you are now recognized as a Junior Assistant on its Staff.

General Superintendent, Forest Preserve District

G. M. Bailey
Director, Chicago Academy of Sciences

Mary Cooper
Curator, Trailside Museum

As a young man volunteering at Trailside, James von der Heydt lived at 421 North Oak Park Avenue in Oak Park. In grade school and high school, he spent many days at Trailside Museum under the tutelage of Mary Cooper. Shown at right in the 1930s, he studied birds native to the area, along with avian taxidermy. Later in life, von der Heydt collected 156 scientific avian specimens, which he donated to the University of Michigan, Ann Arbor. According to records kept by curator Mary Cooper, "James was one of the most dedicated workers at the museum." As an adult, he graduated from Northwestern University with a law degree, and he and his wife, Verna, established a home in Alaska. In the undated photograph below, he is pictured as an appointed judge of the Superior Court of Alaska at Juno. According to his wife, Verna, the "von der" part of their name is a title for the Heydt family from Napoleon for their helping him in some way. (Both, courtesy of Verna von der Heydt.)

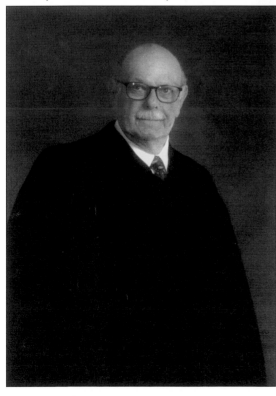

Local and city schools were always taking field trips or classes to Trailside and Thatcher Woods. In the 1930s and 1940s, Ester A. Craigmile was the nature and science supervisor at Willard School in River Forest. Craigmile was well known for making sure River Forest schoolchildren had the Thatcher Woods area on their agenda. This group of children eagerly tries to identify some interesting things in Thatcher Woods. (Courtesy of FPDCC 0005 0019 0142 004 UIC Library.)

The ice is almost completely gone from the Ox Bow Pond in Thatcher Woods in this 1930s photograph. Tramping through the cold and mud, signs of spring could be found. Skunk cabbage would be pushing up its hooded bract (specialized leaves), generating enough heat to survive in the swampy ground. (Courtesy of FPDCC 00 06 0006 0001 UIC Library.)

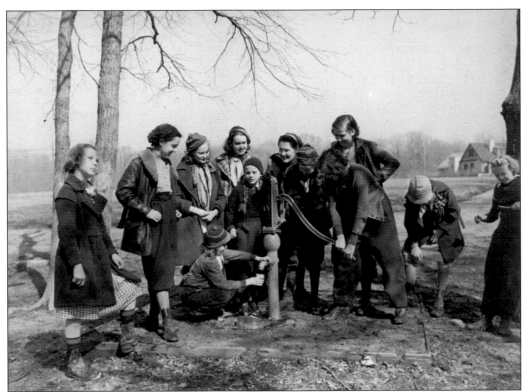

In 1933, a group of Prairie Club junior hikers are cleaning off at one of the pumps located in a field behind the pavilion. According to a journal kept by Mary Cooper, sometimes the younger hikers fell into the river and had to be washed and dried out in the basement of Trailside. (Courtesy of FPDCC 00 01 0006 028 UIC Library.)

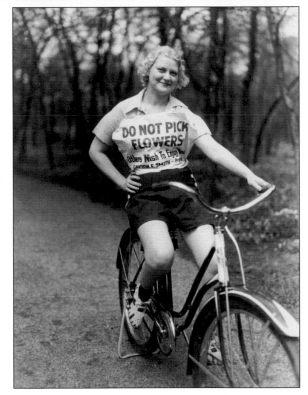

In the 1940s, this young woman posed on a bicycle wearing a "Do not pick flowers, others wish to enjoy them" sign on her shirt. Clayton Smith was the Cook County board president, and the County Forest Preserve District put out a series of nature bulletins asking the public not to pick wildflowers. Some of the reasons listed were: they wilt quickly, many species are destroyed by picking, and their delicate beauty is lost indoors. Leave them for others to enjoy. (Courtesy of FPDCC 00 01 0006 040 UIC Library.)

In 1935, Mary Cooper, now Mary Cooper-Back, is shown turning the reins of Trailside Museum over to Gordon Pearsall. Mary and her husband, Joe Back, departed for the West on April 28, 1935. Even though Mary would write in a round robin letter to her relatives "that she would miss the museum," she knew moving would be good for her husband, Joe, and herself. Pearsall, like Mary, continued the practice of taking in injured animals brought to the museum. According to a *Chicago Tribune* article from October 11, 1937, an older woman stormed into the museum threatening to report him to the Humane Society. Pearsall calmly explained that the animals arrived injured and could not survive in the wild. The woman abandoned her cause and the *Tribune* awarded Pearsall their Politeness Award. (Courtesy of the Historical Society of Oak Park River Forest.)

With a few boards, some rope, and a blanket, this trio prepares to set sail on the murky waters of the lagoon in Thatcher Woods in 1945. From left to right are Billy Doepke, Tommy Jamison, and Alice Jamison; history does not record if they ever made it down to the river. (Courtesy of the Historical Society of Oak Park River Forest)

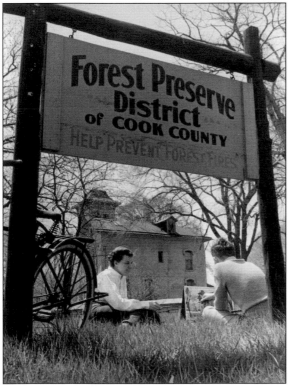

Art students sketch the north side of historical Trailside Museum in this 1950s photograph. Trailside became a popular place for high school and college students to study art, geology, botany, biology, and animal sciences. Area clubs such as the Prairie Club, Camera Club, and Marshall Field's Club met regularly at Trailside Museum. (Courtesy of FPDCC 0001 0011 019 UIC Library.)

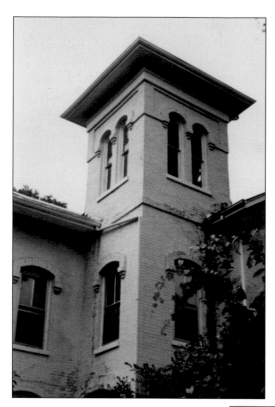

Trailside Museum features a belvedere, or central bay tower, a very distinctive feature of what is high-style American Italianate architecture. In building this beautiful Italianate Victorian in 1874, only the best materials were used. Antoine Bedard, a local contractor, is credited with building this house. The interior 180-degree curved staircase had a handrail that was carved from solid black walnut and consisted of four sections bolted together. When disassembled in the 1990s during a restoration of the museum, it was found that the original craftsman had written "Abraham J. Hoffman" on the rail ends that had been bolted together. (Courtesy of Dawn Waldt.)

Two girls admire waterfowl mounts in this 1930s photograph of an exhibit room at Trailside. Many of the mounts were donated by the Chicago Academy of Sciences. Mary Cooper, the Trailside curator, had proudly created some of the museum exhibits herself. As a part-time technician at the academy prior to taking her position at Trailside, she admired the academy director, Alfred Bailey, for his expertise in bird studies and photographic talents. (Courtesy of FPDCC 00 01 0012 022 UIC Library.)

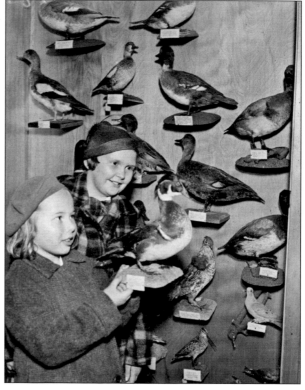

Gordon Pearsall took over the curator position at Trailside Museum on May 9, 1935, after Mary Cooper resigned to head west with her husband, Joe Back. Pearsall was born December 19, 1903, in Batavia, Illinois. Before accepting his position at Trailside, he worked as a guide lecturer in the James Nelson and Louise Raymond Public School and Children's Lecture division. He also worked at Chicago's Field Museum from September 1, 1929, until February 29, 1932, and lived at 1515 West Monroe in Chicago while there. (Courtesy of FPDCC 00 06 0013 0013 UIC Library.)

ATTENDENCE RECORD – TRAILSIDE MUSEUM 1935

DATE	Feb 12 S	13 M	14 T	15 W	16 T	17 F	18 S	19 S	20 M	21 T	22 W	23 T	24 F	25 S	26 S	27 M	28 T
FAMILY GROUPS	5,1,2	2,2	2	2	2	2	2,1		2,2	5,2	3,2	2,2	2				2
BOYS UNDER 14	2,1,2	5,2	1,1	2	1,3,1		3,2	2,1	2,1	1	1,5,2		1,1				3,1
OLDER BOYS	2,1,5	2,1	2	1	2	2	5,1	3,2	2,1,1	1,1,3	1,1	2,2,1	1,2,2			31	1,1,1
BOY SCOUTS (AS A GROUP)														8,11			
MEN	1,1,2	2,3	1,1,1	3,2	3,2	1,1	4,1,2	1,1,2	1,2,7	1,1	3,1,1	1,2,1	2,1,1	1,2,2	1,1	4,4,4	1,4,1
GIRLS UNDER 14	1	1	1		1,1	2	5,1	1,2	1,1	1	1,1	1,1	2,1	3,2	1,1	1,1	
GIRL SCOUTS (AS A GROUP)																	
OLDER GIRLS	1,1,3	1,2					4,2	2,3,2			2,2,3		2	3			
WOMEN	1,1,2	1,2		2		1	1,1	1,1,2,2		1,1,1	1,3,1	1	1	1,2,2			
ORGANIZED GROUPS (OTHER THAN SCOUTS)											7,8						
MIXED PARTIES OF YOUNG PEOPLE	5,6											2,1	2	9			
TOTAL FOR DAY	70	32	11	19	16	12	79	156	23	20	244	27	24	165	191	31	21

Initiated by Trailside curator Mary Cooper and continued by curator Gordon Pearsall was this daily attendance record of people and special interest groups that would visit Trailside on a given day. The daily list helped track the growing popularity of Trailside, which Superintendent Sauers used in part to develop additional nature museums throughout Cook Country. (Courtesy of FPDCC 01 05 0041 0456 001 UIC Library.)

TOTAL NUMBER COLLECTIONS — 1336

Collections — Bird Nests TOTAL 46

North East Room.

1 goldfinch	blue-gray gnatcatcher
songsparrow	barn swallow
field sparrow	robin
long billed marsh wren	chipping sparrow
cardinal	oven bird
2 house wren	red-eyed vireo
phoebe	yellow breasted chat
English sparrow	yellow warbler
kingbird	bluejay
bronze grackle	catbird
bobolink	baltimore oriole
meadowlark	pheasant
ruby throated humming bird	

Shop :
 4 boxes miscelaneous nests

This is a 1933 list of live animals kept in the four main-floor rooms of Trailside Museum compiled by curator Mary Cooper. More details could be found in an accession book. Cooper also kept a work diary of various happenings at the museum. Some days were a little more hectic, as her diary reflects: "Our coon went on a rampage two days ago and ate a fox squirrel, a sunfish, five bullheads, two salamanders, spilled the kerosene. Quite a night . . . a woodchuck broke out of the museum again yesterday. Some damage. Many muddy windows. We are fixing up the back entry for a good strong cage for them . . . Skinned and post mortem a nuthatch. A very small specimen. Cage finished and woodchuck put in." This was taken from *Mary's Way: a Memoir of Mary Cooper-Back* that was compiled and written by her niece, Ruth Mary Lamb. (Left, courtesy of FPDCC 03 01 0032 0476 013 UIC Library; below, courtesy of 01 0032 0476 024 UIC Library.)

Living Specimens * Total 81

North East Room
 1 screech owl
 1 robin
 ? Hermit thrush
 1 virginia rail

South East Room

1 coot	1 blue gill	2 water snakes
2 possums	2 salamanders	1 de Kaye's snake
1 bloodsucker	2 snapping turtles	
12 snails	2 painted turtles	
1 crayfish	3 garter snakes	
5 boxes plants		
9 pots of plants		
2 cocoons		
1 toad		

South West Room

2 skinks	2 prairie rattlers
1 bullfrog	1 water moccasin
2 timber rattle snake	3 garter snakes
2 black pilot snake	2 box turtles
1 alligator	1 geographic terrapin

* for details see accession book

46

This is a continuation of an inventory of animals at Trailside from the previous page. Curator Mary Cooper was a sought-out speaker for the local grade schools in River Forest. Her work diary reflects that she took various live animals such as shrews and snakes to Lincoln School and would prepare slides for the children. (Courtesy of FPDCC 03 01 0032 0476 0025 UIC Library.)

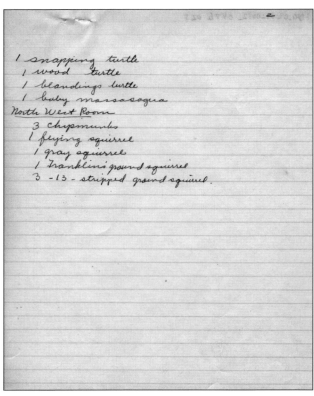

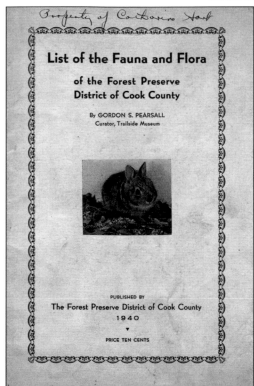

This pamphlet was published by the Forest Preserve District of Cook County in 1940 and written by Gordon Pearsall, then curator of Trailside Museum. This neat little booklet lists all the wildflowers, birds, and little woodland animals that may be found in the Cook County Forest Preserves. The booklet sold for 10¢ and could be found at Trailside Museum and the headquarters for the Forest Preserve District in River Forest. (Courtesy of FPDCC 01 05 0041 0455 001 UIC Library.)

Gail Pohlman, of 733 Clarence Street in Oak Park, is feeding moistened canned dog food to a baby robin in 1945. Some of Pohlman's other assignments at Trailside were raking and hosing the outdoor cages, as well as gathering oak leaves and other materials needed for bedding. (Courtesy Historical Society of Oak Park and River Forest.)

Two students learn about taxidermy in the 1930s. This photograph was taken in the southwest corner of the basement of Trailside. Interested students were taught by Mary Cooper, who learned taxidermy from a talented taxidermist by the name of Earl Wright while she worked at the Chicago Academy of Sciences before taking her position at Trailside. (Courtesy of FPDCC 00 06 0006 0007 UIC Library.)

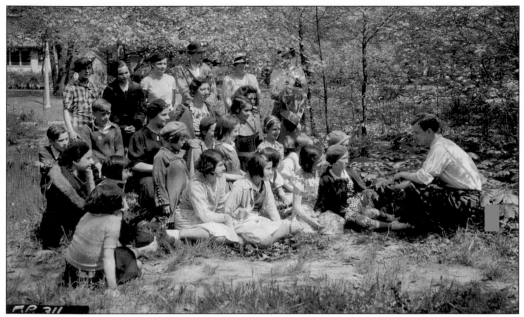

A group of young people listen intently as Trailside assistant curator Paul Ensign gives a talk during an outdoor class. This 1933 photograph was taken in Thatcher Woods just south of Trailside Museum. Groups were regularly scheduled at Trailside; some of the more prestigious groups came from Mortar Board Chapters and Wesleyan University. (Courtesy of FPDCC 00 06 0006 0000 015 UIC Library.)

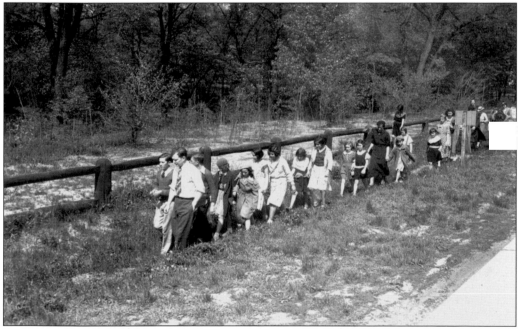

Paul Ensign is shown here leading the same group on a flower and tree walk through the area around Thatcher Woods near Trailside Museum. He was trained in botany, and while working at Trailside part-time, he pursued his medical degree. In June 1935, Ensign resigned to follow his medical career to Kansas City. (Courtesy of FPDCC 00 06 0006 0000 016 UIC Library.)

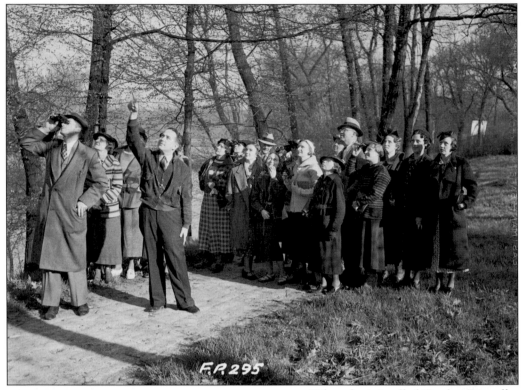

FR 295

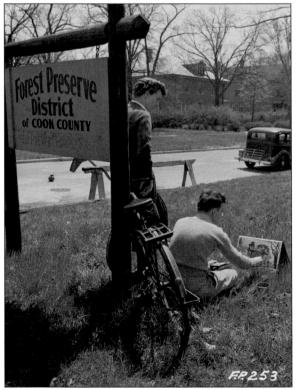

FR 253

"There he is," called Gordon Pearsall as he led a weekly group through Thatcher Woods. Pearsall was referring to the brown-headed cowbird (*Molothrus ater*) in this image from April 10, 1939. The cowbird is a "bad one" because it is lazy and refuses to build its own nest. Females usually lay their eggs in another bird's nest. When the eggs hatch, the little cowbirds then eat all the food left by the bird who originally built the nest for her offspring. (Courtesy of FPDCC 00 06 0006 0000 012 UIC Library.)

A young man leans on a Forest Preserve District sign and watches as another works on a drawing of Trailside Museum. Thatcher Avenue is in view in this 1950s photograph. Students from the Art Institute of Chicago regularly took trips to Trailside to draw and paint Trailside, the woods, and the wildlife. (Courtesy of FPDCC 00 06 0006 0000 002 UIC Library.)

The beauty and serenity of this hiking trail through Thatcher Woods is inviting. The Great Depression was a challenge for the Forest Preserve District. After 1931, the county's tax receipts had shrunk, and it had trouble paying its bills. In addition to Pres. Franklin D. Roosevelt's New Deal, the Forest Preserve District was able to obtain state and federal funds from the National Park Service, the Illinois Emergency Relief Commission, and the Reconstruction Finance Corporation. Among the projects created were beautiful hiking trails. (Courtesy of FPDCC 0005 0009 000 301 UIC Library.)

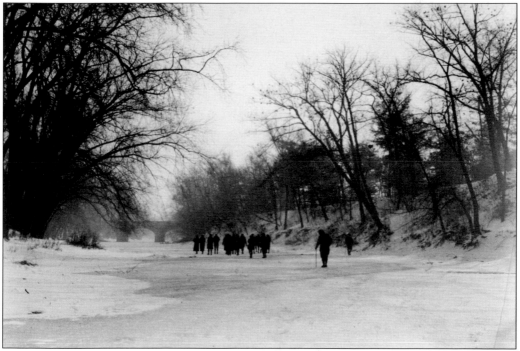

On March 6, 1943, even a driving snow and temperatures of 12 degrees could not keep Audubon members from their regular hike. A mourning dove sang jubilantly as eight members assembled at Trailside Museum. On their hike they only saw six species of birds, but the highlight of the day was the trip to see an Indian mound that noted geologist and ornithologist Isabel Wasson's husband, Theron, also a geologist, had discovered while making a survey of the area. (Courtesy of FPDCC 00 06 0001 0002 055 UIC Library.)

Even on a cold winter's day, Thatcher Woods looks inviting with these picnic tables nestled between the trees. In the 1930s, the CCC constructed picnic tables for the Cook County Forest Preserve District as one of its many projects. Sometimes known as "Roosevelt's Tree Army," nearly three million men served in the CCC from 1933 to 1942. (Courtesy of FPDCC 00 05 0009 0000 308 UIC Library.)

A spring view of the pond shows lovely reflections of the trees in Thatcher Woods Glen. Soon the neighborhood families will be out again with poles in hand, ready to fish. This 1950s photograph shows the warming house that was used primarily by skaters in the winter. (Courtesy of Diane Schulz.)

Behind Trailside Museum to the west there are nature paths running north and south. Stairs leading down to the slough, or pond as some refer to it, can take a hiker around in an oxbow shape, provided heavy rains have not flooded the slough up several stairs as sometimes happens in the spring. (Courtesy of FPDCC 00 06 0002 0006 075 UIC Library.)

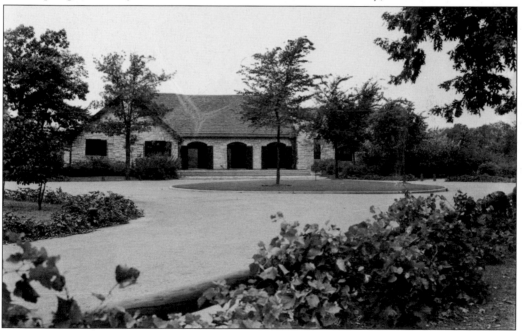

Built in 1931, the Thatcher Woods Pavilion, made in part of limestone, was built using a $2.5 million bond issued to the Cook County Forest Preserve District following a 1930s referendum, according to the Oak Park and River Forest Historical Society. The bonds were used to complete major projects for the Forest Preserve District. (Courtesy of FPDCC 00 05 0011 0037 UIC Library.)

Many hiking clubs were formed in the early part of the development of the Thatcher Woods area in the early 1930s. The group pictured here in front of the Thatcher Woods Pavilion is just one of them. Some of the groups included the Camera Club, Marshall Field's Club, Prairie Club, and the Audubon Society, just to name a few. (Courtesy of FPDCC 00 06 0001 0002 054 UIC Library.)

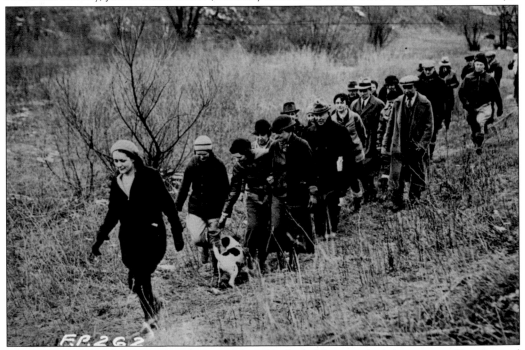

The Prairie Club, whose members met weekly at Trailside Museum, had their main office located at 38 South Dearborn Street, Room 757, in Chicago as of 1935. The club members were active all through the year hiking in Thatcher Woods, even through the winter months. (Courtesy of FPDCC 00 06 0006 0202 UIC Library.)

In this undated photograph, a limestone fence around Trailside Museum appears to be stretching for miles through the woods. With help from the CCC, the fence was built in the mid-1930s. The organization was first established by Congress on March 31, 1933, and provided jobs for young, unemployed men during the Great Depression. (Courtesy of Diane Schulz.)

The limestone fence curls gracefully through the woods around Trailside. By 1934, Trailside proved to be so popular with the public that Alfred Bailey, director of the Chicago Academy of Sciences, wrote a letter to Charles Sauers on December 12, 1934, suggesting that with the success of Trailside, they should put in a few more Trailside Museums throughout the county. (Courtesy of FPDCC 00 05 0011 0030 UIC Library.)

55

Another view of the back of Trailside Museum and the slough includes a workshop separate from the museum in this 1932 photograph. Curator Mary Cooper was quite excited about the workshop because it freed up additional space in the museum for exhibits. (Courtesy of FPDCC 00 06 0001 001B 001 UIC Library.)

A man stands at the northwest point of a half-frozen slough behind Trailside Museum in the 1930s. Trailside stands like a little castle in the woods in the distance. A stairway leading from the slough up to a path lies across the slough directly in front of the man. The slough, part of Thatcher Woods Glen, is beautiful even on a cold winter day. (Courtesy of FPDCC 00 05 0028 0304 025 UIC Library.)

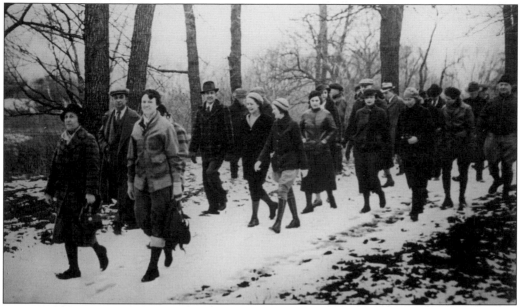

One of the hiking clubs formed in the 1930s was the Marshall Field's Hiking Club. Hiking through Thatcher Woods, young women would wear the latest and most appropriate hiking fashions. The group included employees of Marshall Field and Company's Oak Park store, and called themselves the Forest Preserve Trail Hiking Club. (Courtesy of FPDCC 00 01 0007 038 UIC Library.)

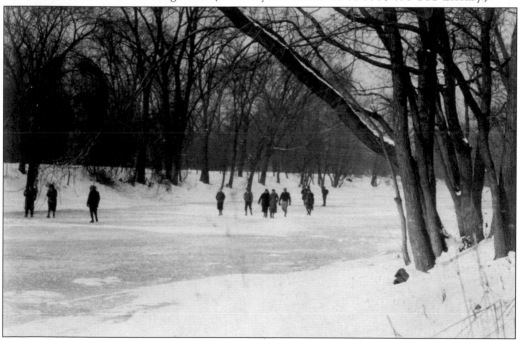

Prairie Club members can be seen hiking across a frozen Des Plaines River near Thatcher Woods in this January 1933 photograph. The group enjoyed winter almost as much as spring, and to them, the study of shrubs and trees without their foliage proved interesting. Afterwards, everyone enjoyed lingering in Trailside Museum studying the wild animals. (Courtesy of FPDCC 00 06 0001 0002 052 UIC Library.)

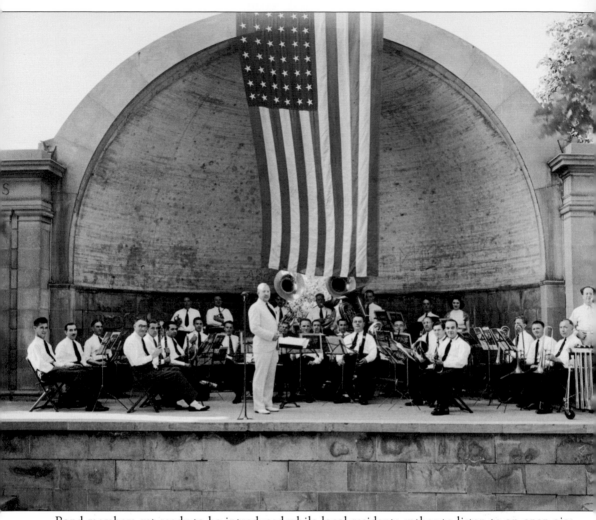

Band members get ready to be introduced while local residents gather to listen to an open-air concert at the Forest Preserve's Cummings Memorial located in River Forest at Harlem and Lake Streets. Located just south of the Forest Preserve District's headquarters, Cummings Memorial and the headquarters building shared the same park-like atmosphere enjoyed by local families. The band shell, which is also used as a theater, was designed in 1924 by Charles White of the firm White and Weber. Ernest Augustus Cummings owned the land and at the time of his death in 1922 at the age of 79, left a bequest of $25,000 for beautification or a memorial on this land, which he sold to the Forest Preserve District. Cummings was an entrepreneur active in banking, real estate, and community development. Because of his importance to the community, there was even a movement to change the name of Harlem Avenue to Cummings, but it never came to fruition. (Courtesy of FPDCC 00 06 0006 0163 UIC Library.)

Three

Indiana Dunes
to Trailside

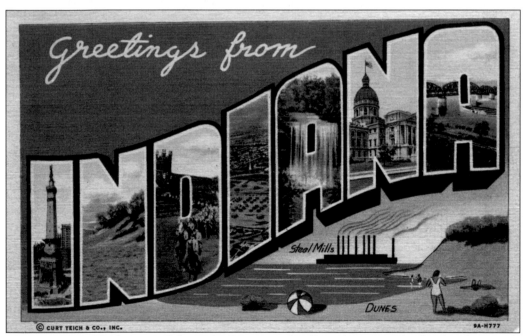

This 1940s Curt Teich postcard shows the Dunes, steel mills, and various other landmarks in each letter of the word spelling out Indiana. Printer Curt Teich was best known for these "Greetings From" postcards in bold, vivid colors. Illustrated in the first "N" are the beautiful Indiana Dunes that Virginia Moe loved and defended. (Author's collection.)

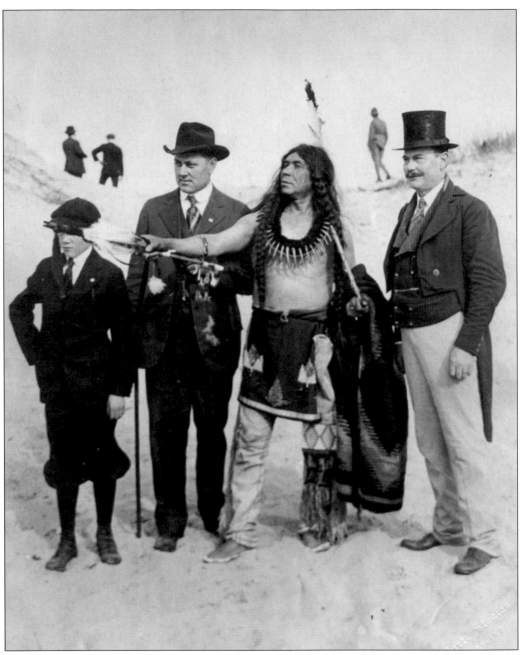

The Historical Pageant of the Dunes took place on May 30, 1917. The event was held to generate support for the creation of a state or national park. Virginia Moe played a part in the pageant at nine years of age. Her mother, Louisa, was in charge of costumes. Aramnis F. Knotts (second from the left) bought much of the land on which US Steel built its Gary plant and also the city of Gary. He was involved in the campaign to establish a national park in the Dunes during the early 20th century. The event was enormous, engaging hundreds of actors and attracting over 40,000 spectators. The pageant association felt they could show people the value and beauty of the Dunes through poetry, music, and dancing. Knotts was also a member of the Prairie Club, a group involved in the formation of the pageant. (Courtesy of Diane Schulz.)

In a special anniversary segment of the *Gary Post-Tribune*, which Virginia Moe wrote on January 4, 1931, she writes about the charm and characteristics of the Dunes that attract thousands of visitors a year: "The Dunes are neither content with color nor contour. It is this constant creating and tearing down which spells the charm of Dune Country. We watch her build with a quick deft hand, small things over night, ripples in sand and miniatures of dunes to come." (Courtesy of FPDCC 00 0002 0001 004 UIC Library.)

Young women enjoy an afternoon at Indiana Dunes State Park on June 13, 1938. In the obituary for Ingwald Moe, Virginia Moe's father, it states that he will be "remembered best and longest for the labors he put forth in collaboration with Mrs. Frank Sheehan, the late William Gleason, and Charles Mahony to obtain the Indiana Dunes State Park for Northwestern Indiana." (Author's collection.)

This postcard depicts a gleeful Virginia Moe as an infant in 1907. During this time, birth announcements were sent out on postcards to family and friends as an economical and expedient way to get the latest news out. In the early 20th century, it only cost a penny to mail a postcard. (Courtesy of Diane Schulz.)

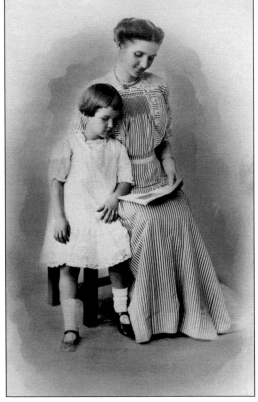

Born on August 17, 1907, in Chicago, Virginia Moe was the youngest of three children. In this 1913 image, she is pictured with her mother, Louisa (Schaible), formerly of Ann Arbor, Michigan. In 1897, Louisa married Ingwald Moe, a Norwegian immigrant and builder. In 1898, Ingwald organized his own contracting firm and moved his family to Gary to build homes for steelworkers. (Courtesy of Diane Schulz.)

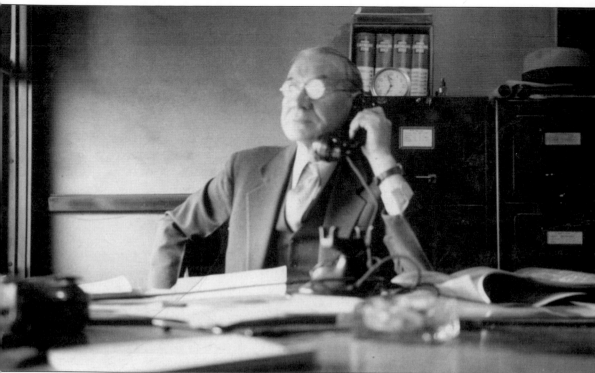

In this 1937 photograph, Ingwald Moe works out of his office at 760 Broadway in Gary. Ingwald Moe played an important role in developing the city of Gary. He was one of the founders of the Gary Commercial Club and the chamber of commerce, and also had a major role in the planning and building of the Gary Gateway. He erected some of the community's largest buildings, including the bathing pavilion at Marquette Park, Gary Theater, Post-Tribune Building, Methodist Hospital, and city hall. He was also proprietor of Gary's first motion picture theater, located at 766 Broadway. In 1922, under his guidance, construction of Route 12, also known as Dunes Highway, began. Ezra Sensibar, Ingwald Moe's good friend, was the construction engineer who worked with him on the project. (Courtesy of Diane Schulz.)

Affectionately embraced as a good fellow by every circle, Ingwald Moe was socially active and won special prominence and regard in the various Masonic brotherhoods of Gary. He had a loveable personality and a boyish enthusiasm for every project he undertook. With his determination to "build things that will last," he dedicated himself to the community and became one of Gary's most valuable citizens. (Courtesy of Diane Schulz.)

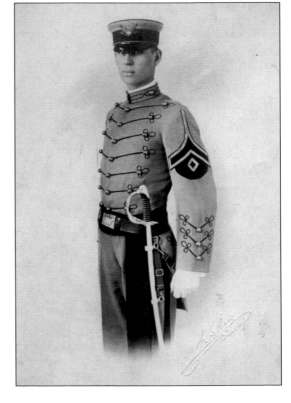

Virginia Moe's brother, Sherwood, pictured here on June 24, 1916, attended Howe Military Academy in Howe, Indiana. After military school, he went to work for a construction company called Powers-Thompson Construction. After the death of their father, Sherwood moved into an apartment in Oak Park at the southwest corner of Kenilworth and Pleasant Streets along with his sister Virginia and mother, Louisa. Soon after, they all moved into Trailside Museum, where Sherwood slept on the third floor and eventually died at an early age. (Courtesy of Diane Schulz.)

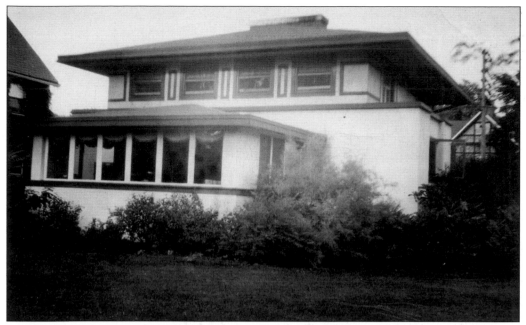

Virginia Moe grew up in what is now known as "the Moe House." Located at the corner of Seventh and Van Buren Streets in Gary, the exact address is 669 Van Buren. Virginia's childhood home, a Frank Lloyd Wright Prairie School–style home, was built between 1909 and 1910 by her father's own General Construction Company. (Courtesy of Diane Schulz.)

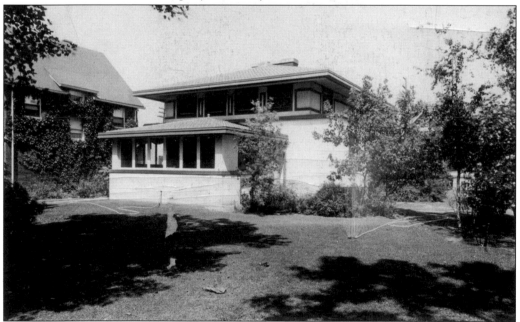

During the building of the Moe family home, Frank Lloyd Wright was away in Europe working on the Wasmuth Edition, a portfolio of his work. Before he left, he hired Hermann Von Holst, a Chicago architect, to take charge of his office. On September 22, 1909, in Oak Park, Wright and Von Holst signed a detailed contract. Two members of Wright's former staff were hired by Von Holst, Marion Mahony and Walter Burley Griffin. (Courtesy of Diane Schulz.)

When the Moes' home was completed, Ingwald Moe and family moved in with all their own furniture, which was mostly Victorian. During the early 1900s, many of Frank Lloyd Wright's clients would furnish their newly built Prairie homes in this way, an anachronism that Wright did not care for. He slowly began to design built-ins, such as seats along the fireplace, and eventually expanded to freestanding tables, chairs, and stools. (Courtesy of Diane Schulz.)

This undated photograph shows another view of the living room of the Moe House. In 1909, the Moe House was just one of many actual and prospective projects Wright had attached to the contract between himself and Herman Von Holst. Von Holst supervised the Moe House along with various other homes, including the Frederick Robie House. (Courtesy of Diane Schulz.)

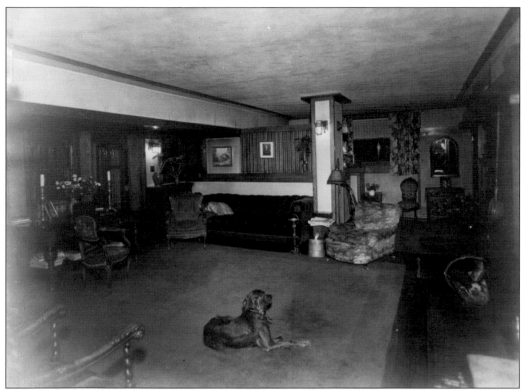

The Moe family dog is relaxing in front of the fireplace in the living room. With the building of the Moe House, a long professional relationship between Wright and Ingwald Moe began in 1916. Moe became the Gary representative of Wright's American Ready-Cut System, also called American System-Built Homes. (Courtesy of Diane Schulz.)

Frank Lloyd Wright was known for creating thoughtfully designed and low-cost houses for middle-class America. In 1905, he designed the Charles A. Brown House, a Prairie School–style home located in Evanston, Illinois. With a few differences to the exterior, the Moe House is said to have been designed with the layout of the Brown House in mind. (Courtesy of Diane Schulz.)

Virginia Moe was a writer for the *Gary Post-Tribune* in the early 1930s. In an article dated January 4, 1931, she describes the Dunes: "It is all elements of lake, beach, dune, and hinterland together, and their endless train of moods and aspects under weather conditions, dawns, sunsets, moon rises, seasonal changes, and the passing of time." (Courtesy of Diane Schulz.)

In the 1940s, a Trailside Museum junior assistant shows two young ladies a striped skunk (*Mephitis mephitis*), one of the museum's residents. When interviewed by the *Gary Post-Tribune* on Tuesday, January 21, 1947, about working at Trailside, Virginia Moe revealed her belief "that things of nature are not accessories to a child's development, but the very fiber of it and that the readiest way to a child's heart is through the animal kingdom." (Courtesy of FPDCC 00 01 0010 016 UIC Library.)

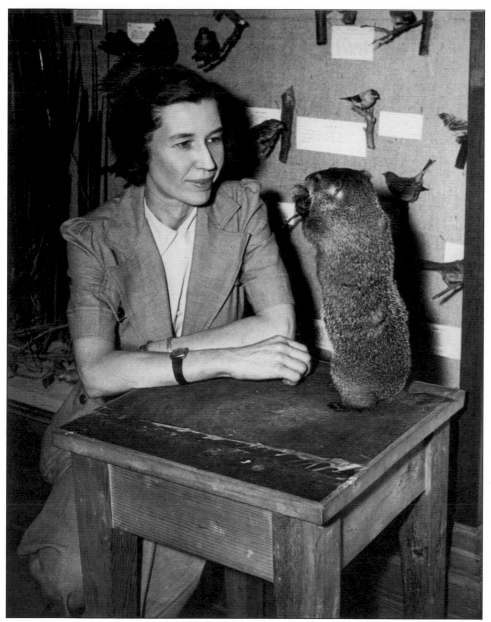

Both Virginia Moe's parents were nature lovers and took an active part in obtaining a national park in northwestern Indiana. Sharing her parent's love of nature and the Indiana Dunes, Virginia spent most of her childhood at the Dunes prior to taking her position at Trailside Museum. In 1939, she accepted an assistant curator position at Trailside Museum. In this early photograph taken at the museum, Chuckles the woodchuck (*Marmota monax*) and Moe seem to be enjoying a quiet moment together. Woodchucks are solitary animals that do not care much to socialize with other animals. Chuckles started a long dynasty of woodchucks that stayed at the museum, all named Chuckles. The original Chuckles was dropped off at the museum's front door after being stolen from his mother's den and then sold to a pet shop. He was quite a character during his short stay at Trailside and was released back into the wild the following June. (Courtesy of Diane Schulz.)

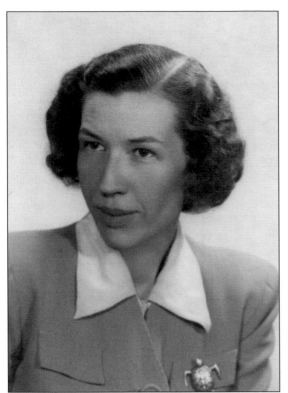

Virginia Moe, better known as Miss Moe, was appointed assistant curator of Trailside Museum in 1939. Experienced as a writer for the *Gary Post-Tribune*, she became editor and publisher of an interesting mimeograph-illustrated pamphlet, *Taproots*. This 1945 photograph of her was used as a publicity shot for a children's book she wrote called *Animal Inn, The Stories of a Trailside Museum*. (Courtesy Diane Schulz.)

This undated photograph reveals how Trailside was quite the peaceable kingdom. It was not unusual to visit Trailside and find animals of different species lounging together on a museum display like this cat, guinea pig, and white rat. These unlikely friendships were one of the reasons the public found Trailside so magical. (Courtesy of FPDCC 00 05 0002 0000 308 UIC Library.)

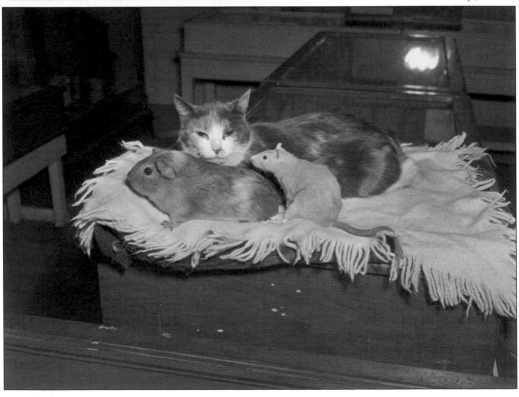

A young orphaned fox squirrel (*Sciurus niger*) named Pumpkin takes formula from his bottle administered by assistant curator Virginia Moe in 1939. With pressure mounting from groups like Friends of Trailside for curator Gordon Pearsall to step down, Moe soon took over the position as curator of Trailside Museum. At this time, she had been living in an apartment in Oak Park. Soon after attending the funeral of her father, Ingwald, on November 20, 1939, Virginia, her mother, Louisa, and brother Sherwood, moved into the second-floor apartment right above Trailside Museum. Her sister, Mrs. Paul Smith, was married at the time and lived in Gary with her husband and two daughters, Dona and Marilyn. Upon his death, Ingwald was cremated in Chicago's Oakwood Cemetery, and his ashes were spread over Mount Baldy in the Indiana Dunes. (Courtesy of FPDCC 00 06 0006 0006 UIC Library.)

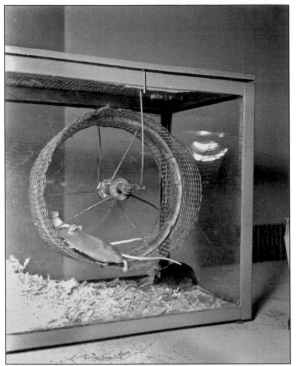

In this undated photograph, two mice share space on their homemade wheel. Many of the cages and animal accessories such as this exercise wheel were handmade by the children who volunteered at Trailside. Most of the materials they used were found objects or scraps from other projects. These cute little mice seem to think their exercise wheel and home is just right. (Courtesy of FPDCC 00 05 0002 0000 307 UIC Library.)

Pictured here is an idyllic early 1940s December morning at Trailside Museum. Powdery snow with lines of black seem to outline the trees, bushes, and outdoor animal cages to the south of the driveway. Trailside was open all year and closed only for Christmas, Easter, and Thanksgiving. (Courtesy of Diane Schulz.)

Four

THE GOLDEN YEARS

In this 1942 photograph, a crow named Captain Midnight appears to be taking a morsel from Virginia Moe's mouth. Unable to be released back to the wild, Captain Midnight was a regular at the Trailside Museum Nursery School. Enrollment included 15 children, and sessions lasted eight weeks. Other regulars in class were Chuckles the woodchuck and Mike the squirrel. (Courtesy of Diane Schulz.)

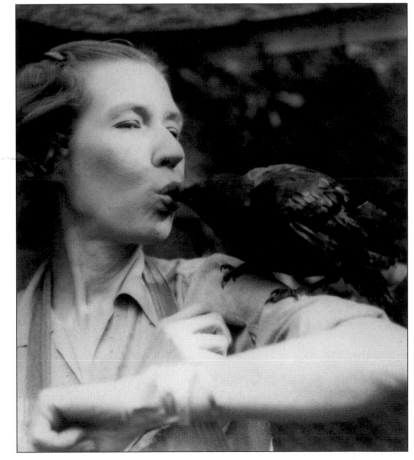

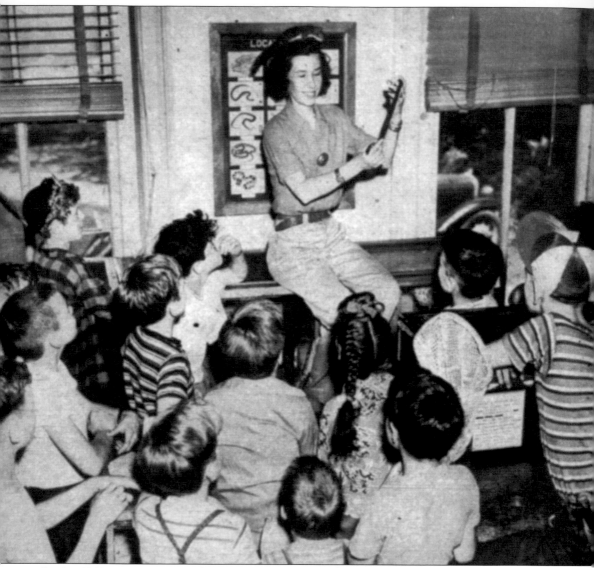

In the 1940s, Buster Brown the American red squirrel (*Tamiasciurus hudsonicus*) sits on top of Virginia Moe's head as she gives a lecture to a group of children. Whenever groups of children would visit Trailside, Moe generally would perch atop a cage and lecture on snakes and other animals. She found that the boys liked the snakes while the girls enjoyed the rabbits. Many times the children would want to stay and help out with the animals. On any given day, Trailside could see up to 60 helpers, mostly boys, cleaning cages, feeding box turtles, or gathering clover for the wild cottontails. Other daily chores included preparing food and washing cages with soap and water. Any time a new animal came to the museum, children would have to find the proper cage furnishings, such as the right nest box or branches that would best simulate the animal's natural surroundings. (Courtesy of the Historical Society of Oak Park and River Forest.)

In 1946, Virginia Moe dedicated her book *Animal Inn* to "Littlejohn," shown sitting on the stairs with a fox and another unidentified boy. Littlejohn was a nickname for Jack Higgins, and he spent almost every day of his childhood at Trailside. In her book dedication, Moe described Littlejohn as a "Huckleberry Pan" and a good companion. (Courtesy of FPDCC 00 01 0012 005 UIC Library.)

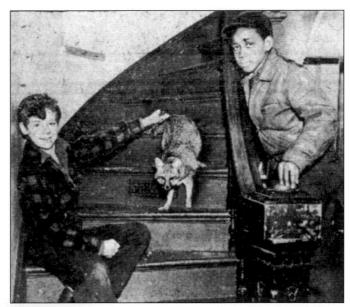

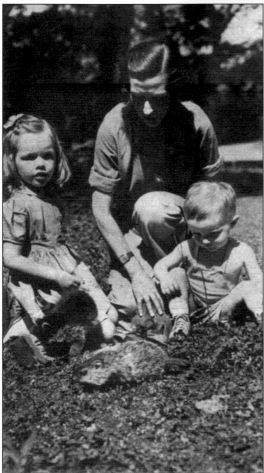

In this 1940s photograph, Virginia Moe teaches children to love the animals she loves. Baby Roger Scott is watching the woodchuck while Moe pets a prairie dog, and Annie Richards discovers a baby raccoon. All three little animals lived happily together in the same cage. These young children were part of a tot class held at the museum every week. (Courtesy Historical Society of Oak Park and River Forest.)

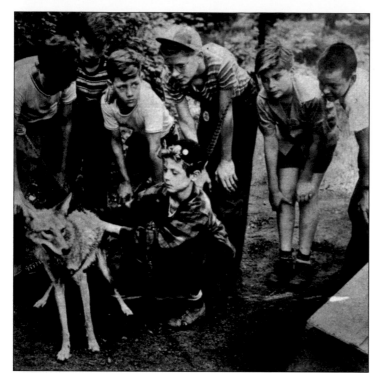

A group of children in the 1940s find Rover, a prairie wolf (coyote), fascinating. Out of his cage and on a leash, children were invited to pet him. Pictured with their new lupine friend are, from left to right, Dan Creedon, Joe Fleming, Don Bourgh, Jack Higgins (crouching), Gene Rowick, George Moxon, and Stacey Thompson. (Courtesy of the Historical Society of Oak Park and River Forest.)

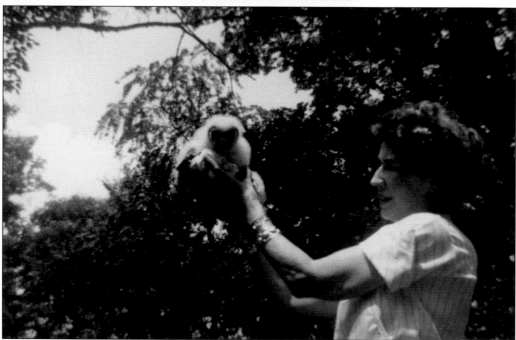

This young barn owl (*Tyto alba*) being held up by Virginia Moe in the 1940s looks more like a ball of fluff than an owl. Information could not be found on how this little one actually arrived at Trailside, but it is probable that its mother met with some type of accident that prevented her from returning to the nest. Raised with other barn owls, he would be sure to be released one day when he was old enough. (Courtesy of Diane Schulz.)

Another 1940s photograph shows Lyman Carpenter administering first aid to the injured wing of a screech owl. Carpenter's dedication to the study of animals and their habitats won him a job as an assistant curator at the museum. Children found that the experience they got at Trailside helped them land college science scholarships and laboratory grants. (Courtesy of the Historical Society of Oak Park and River Forest.)

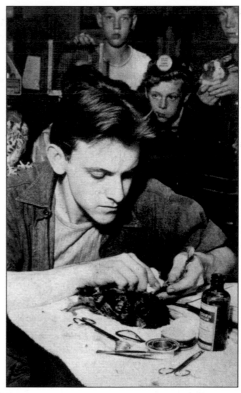

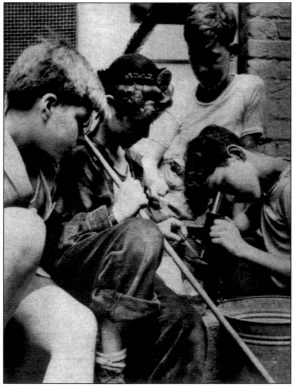

Pictured here in the 1940s are, from left to right, George Moxon, Jack Higgins, Don Bourget, and Dan Creedon examining a specimen they caught at the pond earlier in the day. All the boys and girls who came to the museum on a daily basis were given official badges as junior assistants. At this time, Moe had over 60 boys and girls helping at the museum. (Courtesy of the Historical Society of Oak Park and River Forest.)

In 1946, a series of publicity images were taken by photographers to be used in various papers to promote Virginia Moe's new book, *Animal Inn*. The back of this photograph was stamped *International News Photos*. This young eastern screech owl (*Megascops asio*) does not seem to be bothered by the fact that he is dressed up like a character out of the *Harry Potter* series. (Courtesy of Diane Schulz.)

With a talent for writing about animals that appealed to youngsters, Virginia Moe, pictured here with one of her dogs in the early 1940s, was asked to write for a 1961 edition of a *World Book Encyclopedia* series called *Childcraft: The How and Why Series Created Especially for Children, Animals of Fields and Woods*, which described some of the wild animals that can be found in parks, fields, and woods. (Courtesy of Diane Schulz.)

Taking a stroll with her dog, Virginia Moe is seen in the driveway of Trailside in 1942. Before taking her position at Trailside, she studied at Kenwood-Loring School for Girls in Chicago and took ballet from Adolph Bolm, ballet master of the Chicago Civic Opera Company. (Courtesy of Diane Schulz.)

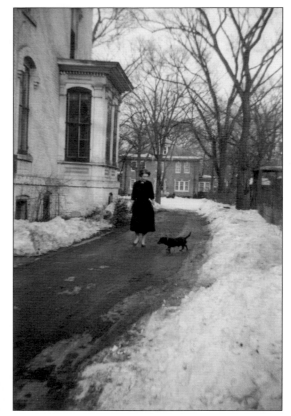

In 1943, five tiny skunks were brought into Trailside by a caretaker of an old monument factory in a suburb just outside Chicago. They had greeted him when he arrived for work. Sure that their mother had met with some accident, he gathered them up and brought them to Trailside. Tar Baby, shown here with Virginia Moe, would stay on at the museum as a permanent guest. (Courtesy of Diane Schulz.)

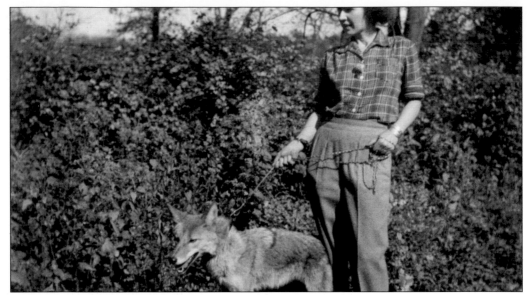

Rover the prairie wolf is seen here in the early 1940s with Virginia Moe. It is unknown how Rover came to live at Trailside, but many times well-meaning people would find a young one and think they could raise it. By the time they realized wild animals do not make good pets, it was too late. They can very rarely be released into the wild again. (Courtesy of Diane Schulz.)

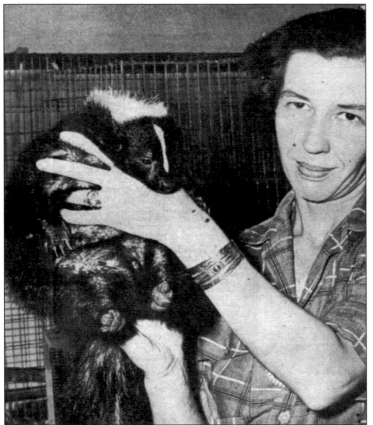

Domino the skunk, shown in 1946 with Virginia Moe, was one of the official greeters at Trailside. Domino usually had the run of the museum during the day. At night he lived in the museum's telephone booth with his spouse, Tar Baby. Deprived of their natural means for showing displeasure, Moe described them as being quite affectionate. (Courtesy of Historical Society of Oak Park and River Forest.)

The sign above Chuckles the woodchuck read, "How much wood could a woodchuck chuck if a woodchuck could chuck wood?" In this 1930s photograph of a young girl holding Chuckles, the little mammal seems to be smiling for the photographer. Violet Klein from Berwyn, Illinois, brought the roly-poly woodchuck to Trailside after finding him by the roadside as a baby. (Courtesy of FPDCC 00 06 0006 0000 011 UIC Library.)

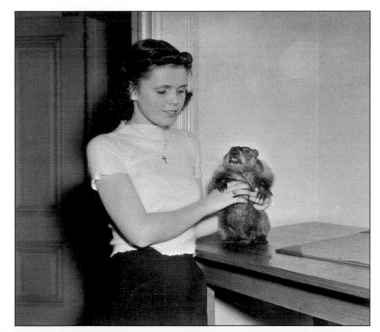

This peccary seems to be wondering if Virginia Moe is holding a special treat for him in her hand in this 1946 image. Photographed in one of the main floor rooms of Trailside, it is unknown if this peccary is a collared or Chacoan. It is also unknown how he ended up at Trailside. Peccaries (genus *Tayassiet*) are pig-like mammals native to the Americas. (Courtesy of Diane Schultz.)

Two young boys try to coax this outdoor fox closer in the 1950s. Many of the original outdoor cages were designed by the Chicago Academy of Sciences, which partnered with the Cook County Forest Preserve District in the early 1930s. Many outdoor cages were built with a recommendation from the academy. Other exhibits, such as the outdoor turtle pond, never were built. (Courtesy of FPDCC 00 06 0001 001B 012 UIC Library.)

This young raccoon nuzzles beside Virginia Moe's neck in April 1964. When Moe first arrived at Trailside as assistant curator, a male raccoon by the name of Tarzan was the oldest animal there. One of her first chores was to remove an ancient bandage from his foot, which had been broken when he was hit by a car. (Courtesy of Diane Schulz.)

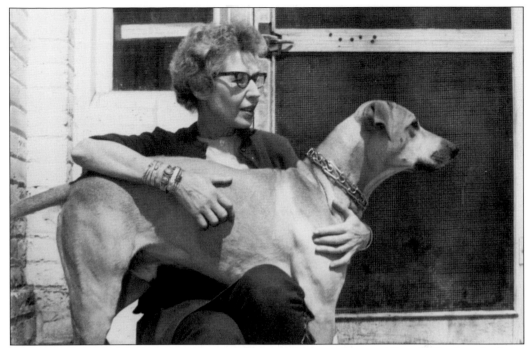

Samson, a Rhodesian ridgeback and one of Virginia Moe's pet dogs, cuddles with her on the front porch of the museum in this undated photograph. Even though Trailside was a center for sick, injured, and displaced wild animals, Moe lived upstairs at the museum and had her own pet dogs and cats that lived with her. (Courtesy of Diane Schulz.)

In this undated photograph, Chuckles, one of the many woodchucks bearing that name throughout the years at Trailside, takes comfort in cuddling with one of the museum cats. Visitors to Trailside always delighted in seeing the various species all getting along and even living in the same quarters together. (Courtesy of Diane Schulz.)

This 1960s photograph showcases a beautiful December afternoon outside of Trailside Museum. The driveway leads west past the museum to the frozen pond, which ice skaters use frequently during winter months. Virginia Moe used to enjoy watching the skaters from her kitchen window when she finished work at 5:00 p.m. (Courtesy of Diane Schulz.)

This 1970s paper dove was one of the many crafts Virginia Moe made at Christmastime to decorate the bay windows in Trailside Museum. It was always a joyous surprise for the junior assistants to receive several in the mail from her. The scent of evergreens was everywhere as she decorated the interior windows and circular staircase with holiday greens. Always important to Virginia Moe, the junior assistants would have their own information on file so they could be called upon any time an extra hand was needed. Moe would also include their astrological signs in their file. (Author's collection.)

Always a creative writer, this 1972 Christmas card showcased Virginia Moe's talent for writing poetry. Every Christmas Eve, she would close the museum early after all the cages were cleaned and the animals fed. The junior assistants were invited upstairs to decorate her tree, polish her silverware, and listen to stories of the magnificent parties held at the museum in days gone by. Moe was also a talented painter. In 1941, she sketched Christmas cards, some of which she sent to members of the editorial staff of local newspapers. Surrounded by sketches of raccoons, skunks, possums, owls, turtles, and even mice, were the words: "Some of our cousins who also live in the Cook County Forest Preserves have stored up a winter supply of food or have picked out a warm place to sleep. They are happy. We are happy too, because we have stored up another year's supply of humans who think it is very important to count us among their friends and since you are one of them we are sending you, Holiday Greetings from Trailside Museum." (Author's collection.)

ZOOKEEPER'S CAROL FOR SAINT NOAH

Hurray for father Noah
The first to run a zoo,
Hurray for Mrs. Noah
Who had to cook and do.

The Noahs surely loved them
Who came by two and two,
For they welcomed all and sundry
To the famous floating zoo.

So here's a cheer for Noah
Who flew the snow white dove.
The first to show the world that
There were creatures man should love!

V. M.

peace on earth

Best wishes and Thanks for all your help

"Miss Moe" Trailside 72

This 1974 list was a sample of chores for junior assistants. Most of the chores and meals at Trailside were completed in the morning between 8:00 a.m. and 10:00 a.m., but some animals needed more food in the afternoon. On most days, the work for junior assistants went from 8:00 a.m. until 5:00 p.m., with an hour off for lunch. Virginia Moe paid them out of her own pocket. Her assistants earned $5 for a half day or $7.50 for a full day's work. (Author's collection.)

"All babies are my babies" was the motto of Footsie, one of Trailside's pet cats. In this 1963 photograph, Footsie is visiting one of the motherless babies she reared, a white rat. In addition to her own kittens, Footsie would raise squirrel and raccoon babies whose own mothers were hit by cars, killed by a neighborhood dog, or poisoned. (Author's collection.)

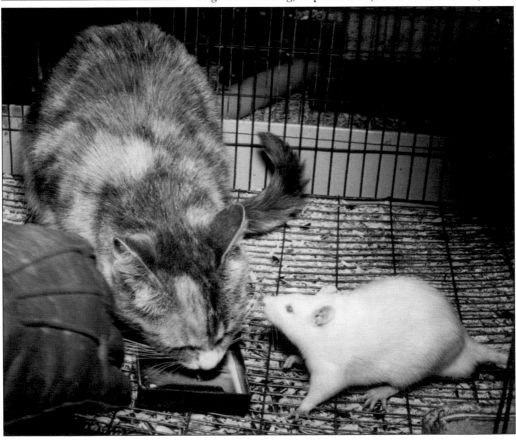

This early 1950s image shows the back of trailside and Virginia Moe's old station wagon. The fence posts mark the entrance to the pond leading down into the Thatcher Glen. Paths could also be found leading north and south through beautiful Thatcher Woods. (Courtesy of Diane Schulz.)

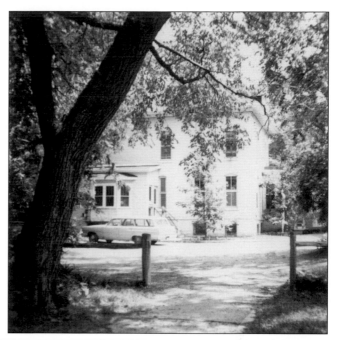

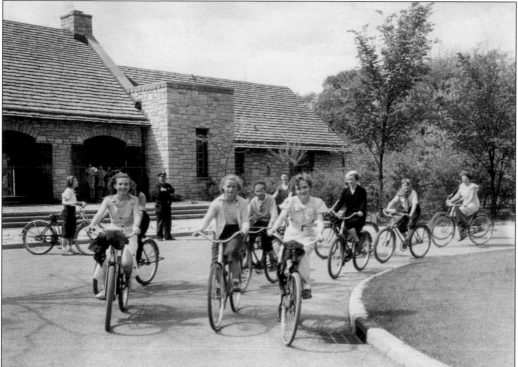

From left to right, Helen Andrew, Wanda Berman, and Mary Donegan lead the way from the Thatcher Woods Pavilion on their way to a bike jamboree. Almost 20 different cycle clubs planned to meet up in Thatcher Woods to draw up plans for "Parade to the Pageant," located in Garfield Park. The parade, sponsored by the *Chicago Daily Times*, took place August 8, 1939. (Courtesy of FPDCC 00 06 0001 0002 082 UIC Library.)

Alfie, in her outdoor cage in 1972, seems alert in one image and content to enjoy the warmth of the summer in the other. Alfie was very young when someone brought her to Trailside after her den was destroyed by a bulldozer. Too tame to be released in the wild, Alfie seemed content adjusting to her life at the museum. Alfie lived in an outdoor cage during the day but was always brought into her smaller cage at night due to vandals breaking into some of the outdoor cages after dark. Alfie never objected to being carried in at night but Virginia Moe always noted, "just in case she might, it is always one of the day's adventures." (Both, courtesy of Diane Schulz.)

These 1969 and 1973 Scout-O-Rama badges are examples of the Boy Scout badges that could be earned through the Thatcher Woods Area Council. In 1993, the Des Plaines Valley Council was formed through a merger of the West Suburban Council and the Thatcher Woods Council. At the inception of Trailside Museum, the Boy Scouts were an integral part of many of their programs and exhibits. A local newspaper article from 1939 talked about the scouts collecting snakes indigenous to the Thatcher Woods area to be displayed at Trailside Museum. The list of snakes included a Kirkland water snake, a blue racer, a hog-nosed snake, and three pilot black snakes. The scouts were participating in a Reptile Study merit badge class held at Trailside. (Both, author's collection.)

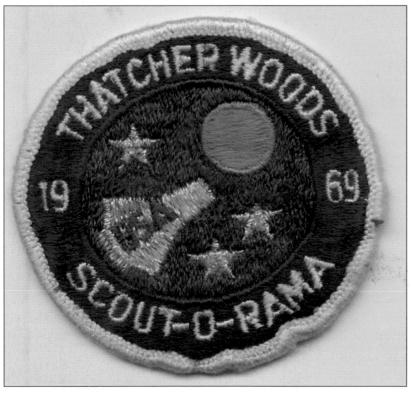

Nice spring weather brings out this group of cyclists crossing a small bridge in Thatcher Woods, just north of Trailside and just south of the Thatcher Woods Pavilion. Groups could ride their bikes to Trailside for a visit with the animals, then head over for a picnic in Thatcher Woods. (Courtesy of FPDCC 00 06 0001 0002 079 UIC Library.)

A family from Chicago's Austin neighborhood enjoys a relaxing afternoon reading and barbecuing in Thatcher Woods in the 1960s. Located in River Forest and only five miles from Chicago, Thatcher Woods is an accessible destination for families with small children. Trailside was within walking distance from a great picnic area. (Courtesy of Monica Affleck.)

Every summer, families and neighborhood friends would ride their bikes five miles to Thatcher Woods. With forest preserve grills already stationed in the woods, all that was needed was to find long enough sticks for the marshmallows to be roasted. This 1959 photograph shows a forest preserve grill already in place. (Courtesy of Monica Affleck.)

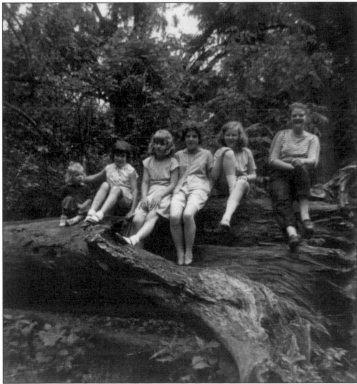

In 1959, children pose in nature's playground, better known as Thatcher Woods. The area is made up of Thatcher Woods, Thatcher Woods Glen, Grand Army of the Republic Woods, and Thomas Jefferson Woods. Thatcher Woods is comprised of 245 woodland acres along the Des Plaines River. The Des Plaines River Valley is mostly made up of flood plain forests, while oak savannas cover the highlands. (Courtesy of Monica Affleck.)

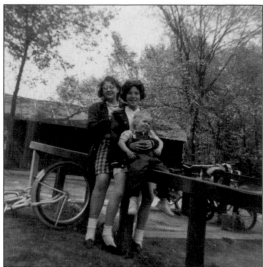

A bike rail becomes playground equipment for children in this 1959 image. The old shack once used as a warming house in winter for ice skaters can be seen in the background. The pond, just south of the warming house, is located in Thatcher Woods Glen. (Courtesy of Monica Affleck.)

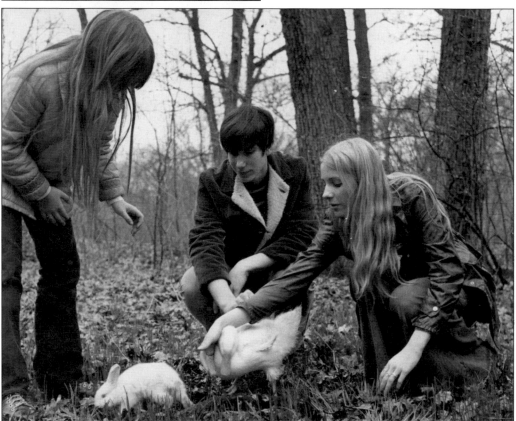

Pictured here from left to right are Beth Dorsett, David Ditchfield, and Jane Affleck rescuing a domestic duck and rabbit that were dumped in Thatcher Woods on March 21, 1974. Many times people buy domestic rabbits and ducks as gifts for their children around the holidays, particularly Easter. After growing tired of taking care of them, they release them in the woods thinking they will survive with the other wild animals. Unfortunately, they would have perished if this trio had not come to their rescue. (Author's collection.)

Three-year-old Blake Oliver tells his mother about one of the interesting things he learned about baby bunnies in the special nursery class. Virginia Moe taught smaller children each Friday during the winter months. (Courtesy of the Historical Society of Oak Park and River Forest.)

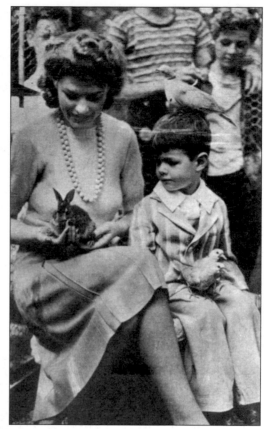

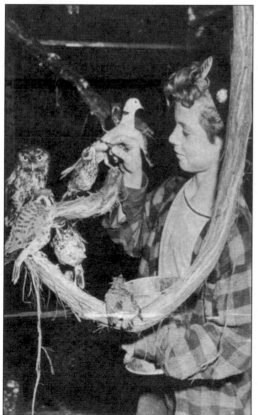

Jack "Littlejohn" Higgins finds the phrase "feathered friends" is more than just an expression. In 1947, Jack is taking care of three baby robins, two owls, and a dove that are enjoying their meal in one of the museum's outdoor cages. (Courtesy of the Historical Society of Oak Park and River Forest.)

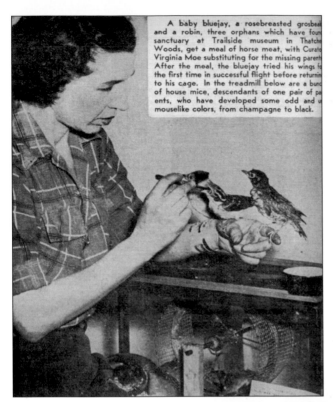

A baby bluejay, a rosebreasted grosbeak and a robin, three orphans which have found sanctuary at Trailside museum in Thatcher Woods, get a meal of horse meat, with Curator Virginia Moe substituting for the missing parents. After the meal, the bluejay tried his wings for the first time in successful flight before returning to his cage. In the treadmill below are a bunch of house mice, descendants of one pair of parents, who have developed some odd and unmouselike colors, from champagne to black.

One of many books Virginia Moe kept in a glass bookcase behind her desk was *Stroud's Digest on the Diseases of Birds*. Robert Stroud, also known as the infamous "Birdman of Alcatraz," wrote a letter from Alcatraz on March 5, 1945, to his sister, Mamie E. Stroud. Robert Stroud wrote, "I also had a letter from Miss Virginia Moe, Curator of the Trailside Museum of Natural History. She said it was a pleasure to read a book written by a practical person who is also a careful investigator, that most scientific writers just read what others have written and then passed the other man's errors, as well as their own, along to an already gullible public." (Courtesy of the Historical Society of Oak Park and River Forest.)

Screech owls look imperiously at visitor Paul Gonzalez of Chicago. The sign on their cage reads, "Screech owls are common in the area and are night creatures. They eat mice and other small rodents." This image is from a special feature done on Trailside in a 1940s *Pioneer Press* edition. (Courtesy of the Historical Society of Oak Park and River Forest.)

The sign on this outdoor cage reads, "Playpen for animals and children." Benches are placed inside the cage for when children visit the little animals. The woodland folk seen here in 1947 are a woodchuck (on the floor at the left), a baby rabbit, a robin, and a turtle. The boy at right is holding a raccoon, and over his head are a dove and an owl. (Courtesy of the Historical Society of Oak Park and River Forest.)

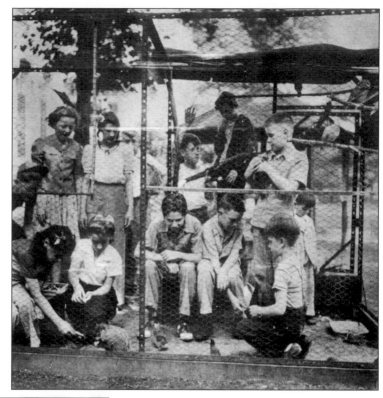

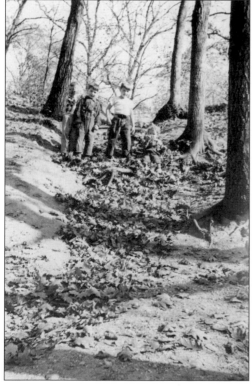

River Forest's own Dooley Brothers can be seen in this autumn 1950 image. Bill, Joe, and Dennis are playing in Thatcher Woods at Chicago and Thatcher Avenues right next to Trailside. As children, the Dooleys were always visiting Trailside, and some of the brothers became talented musicians. By the mid-1960s, the Dooley Brothers had hit the folk music scene, playing in the same circles as Steve Goodman and John Prine. (Courtesy of Jim Dooley.)

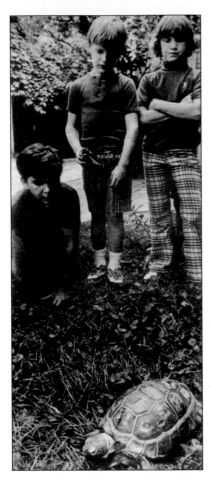

This 1974 image is from the *Forest Leaves* newspaper. These youngsters watch a gopher tortoise (*Gopherus polyphemus*), which is from the Southwest, munching on the grass outside of Trailside Museum. In the summertime, the tortoise got a weekly bath and spent time outside. He usually moved freely about the museum and slept under Moe's desk. (Courtesy of the Historical Society of Oak Park and River Forest.)

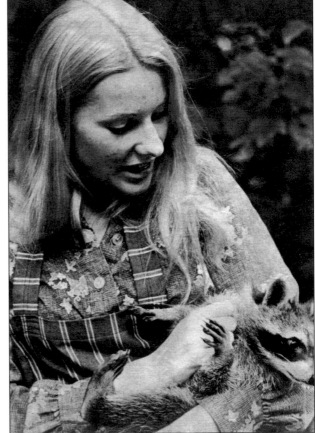

Jane Affleck plays with Pooh Bear, a raccoon and one of her furry friends at Trailside Museum, in 1974. Pooh Bear was one of the museum's educational animals, and he was frequently handled by the junior assistants. Affleck was one of Pooh Bear's handlers since he was brought in as a baby. (Author's collection.)

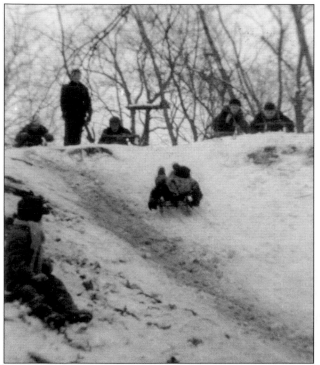

In the 1950s, several slopes by Trailside Museum down to the pond were the designated sledding area for River Forest kids. The slope pictured above was named "Devil's Drop." The sledders would speed down right out to the frozen pond. Some of the sledders in this image grew up to be widely known singers the Dooley Brothers. Jim Dooley wrote and recorded several songs about Thatcher Woods called *Greenwood* and *Forest Mirth*. Jim still roams these woods today with pen and camera, along with his wife, Anna, and their children, Jimmy and Claire. The Dooley Brothers' mother, Avis McMullin Dooley, known professionally as Avis Mac, was a famous artist and also a frequent visitor to Trailside. In 1936, Avis painted a series of paper dolls for Whitman Publishing Company in Chicago. Shown at right is a cutout doll and book cover of one of the popular Dionne Quintuplets featuring "Cecile." (Above left, courtesy Jim Dooley; above right and below, author's collection.)

These 1963 pastel paintings of Thatcher Woods near Trailside Museum are by Avis McMullin Dooley, a painter whose portraits in the 1920s and 1930s captured the spirit of the era and many of its most colorful personalities. In her later years, she shifted to pastel landscapes, some of which she painted in Thatcher Woods. Dooley was a resident of River Forest from 1909 to 2000. She was a devoted member of the Audubon Society, and as early as the 1920s, she would be out in Thatcher Woods as part of a group of birdwatchers. She knew those woods well and was an acquaintance of Virginia Moe and Isabel Wasson. She taught her children the beauty of those woods and its denizens. Even in her 80s, when there was a blizzard she would jump in the car with her sons and head to the area around Trailside to watch and listen to the beautiful quietness of the snowstorm. The scene at left shows a slope near Trailside after a fresh snowfall. (Both, courtesy of Jim Dooley.)

This little stone bridge in Thatcher Woods is near the entrance of the road to Thatcher Field. It was the scene of many a tryst in the old days. Jim Dooley's mother, Avis, always told the story of how in 1937 his father was courting her. The couple always walked through the woods, and one day they sat on the bridge holding hands and talking. They were discussing the rich history of the American Indians of this area, and Jim's father told the story of a young Indian couple. In the story, when the young Indian couple was falling in love they probably walked this same path long ago, as they were now. Midway through the story, Jim's father then said, "Speaking of that—I would be honored. Would you like to be my squaw?" They were married a year later. (Courtesy of Jim Dooley.)

Near dusk in Thatcher Woods, this white-tailed deer (*Odocoileus virginianus*) seems to pose for the camera. Virginia Moe only accepted one deer in all the years she worked at Trailside. During the 1940s, an Army lieutenant from Michigan found a little fawn still damp from his birth trying to suckle from his dead mother along a busy highway. The Army veterinarians took care of him until the lieutenant received his shipping orders. Bambi, as the fawn was called, soon arrived at Trailside to the delight of all the junior assistants. (Courtesy of Jim Dooley.)

This lovely image shows the field and woods behind the Thatcher Woods Pavilion. In 1917, when the Cook County Forest Preserve District bought the land from the Thatcher family, it had been kept in its natural state and had not been logged, plowed, or grazed. The same types of plants and animals that live there today have lived there for hundreds of years. (Courtesy of Jim Dooley.)

Five

THE MOVEMENT TO SAVE TRAILSIDE

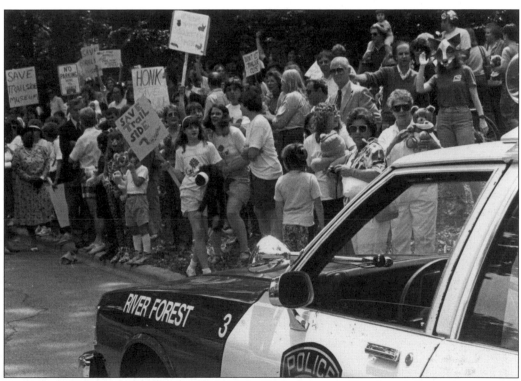

In a *Chicago Tribune* article from April 4, 1986, Jay Pridmore wrote, "People and places of uncommon virtue are beset by the same fate. Because they are rare, they often are overwhelmed by the rest of the world, so much so that their character is tested. We all know people and places like this. There is also a museum facing the same kind of test." The decision by Cook County Forest Preserve district superintendent Arthur Janura to quietly close Trailside Museum hit a nerve with residents from Oak Park, River Forest, and surrounding communities. In this 1989 photograph, the protesting of Trailside's closure garnered coverage from the *Chicago Tribune*, the *Chicago Sun-Times*, local papers, and Paul Harvey's national radio broadcasts. (Courtesy of Dawn Waldt.)

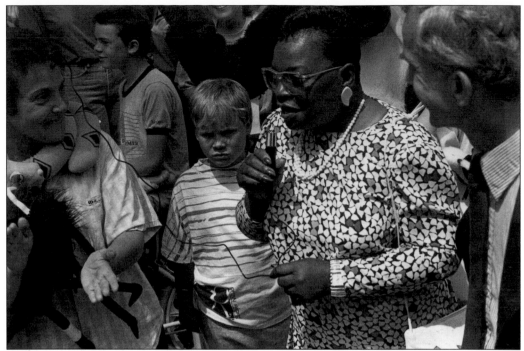

During a 1989 protest to save Trailside Museum, two Cook County commissioners came out to speak on behalf of their constituents. The champions were commissioner Bobbie Steele (holding the microphone) and to the right, commissioner Joseph Matthewson (also pictured below). Both Matthewson, a Republican, and Steele, a Democrat, are credited with supporting the wildlife program at Trailside. They both were also early supporters of the grassroots citizen organizations created to save Trailside Museum. While Steele played an integral part in saving Trailside from start to finish, Matthewson's ties were close to home, as his wife was a Trailside follower and frequent visitor to Trailside as a child. Also pictured is Bonnie Brenn-White with a toy snake around her neck. Bonnie was one of the original organizers and leaders of the grassroots movement to save Trailside. (Both, courtesy of *Wednesday Journal*.)

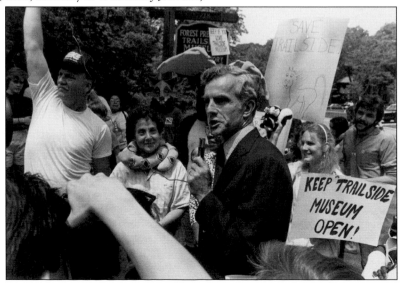

In 1989, hundreds of people from the Oak Park and River Forest Communities showed up to protest the closing of Trailside Museum. Children and adults brought stuffed animals with bandages and homemade signs. There were so many people that the driveway in front of Trailside was filled and people spilled out onto Thatcher Avenue. River Forest police were called by organizers to let them know a peaceful protest was happening. (Courtesy of Dawn Waldt.)

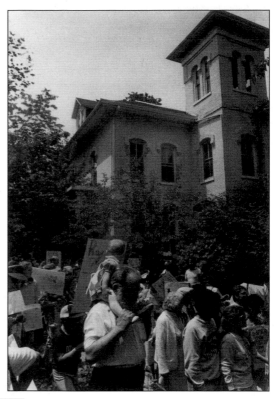

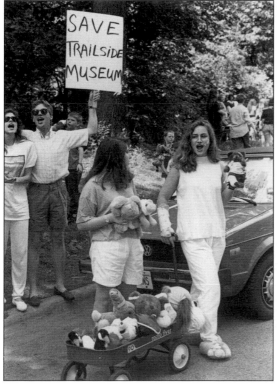

According to a *Pioneer Press* article dated May 24, 1989, the decision to close down Trailside Museum "stirred outcry from area residents." Bonnie Brenn-White of Oak Park said she and four helpers circulated petitions in downtown Oak Park and 524 signatures were collected on Saturday. Annette McNealy, a Trailside volunteer with her children, collected 400 signatures on Sunday. (Courtesy of Dawn Waldt.)

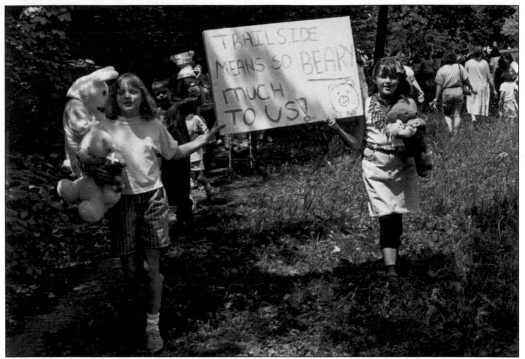

Some people called it "a Children's Crusade" when they referred to the efforts by the community to save Trailside Museum, but in this image from June 4, 1989, not everyone was a child. Many adults who protested were once children who had visited Trailside. As adults, they brought their children and grandchildren to visit the animals. On this day, more than 200 adults and children were chanting "Save Trailside." (Courtesy of Dawn Waldt.)

A family carries a sign reading "Bless the Beasts and the Children, save Trailside," in 1989. The Cook County Forest Preserve District had been planning on quietly phasing out Trailside, according to superintendent of conservation Ray Schwartz. After the US Department of Agriculture cited the Forest Preserve District with sanitary violations, the Forest Preserve District decided to speed up the closing of Trailside rather than make the necessary repairs. (Courtesy of Dawn Waldt.)

Small children hold up a sign reading, "Trailside Means so Beary Much to Us" during a teddy bear parade. The parade included hundreds of children carrying their favorite stuffed animals with bandages to represent all the injured animals Trailside harbored and nurtured. (Courtesy of Dawn Waldt.)

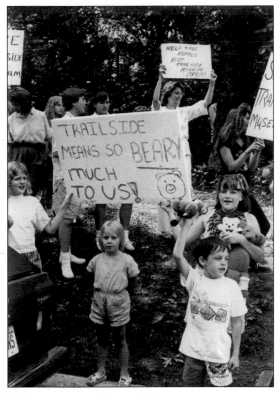

Old and young alike came out to support their beloved museum and longtime curator Virginia Moe in 1989. At the time, there was no other place like Trailside where one could bring an injured wild animal. Everyone was shocked that the Cook County Forest Preserve District would simply shutter their museum. (Courtesy of Dawn Waldt.)

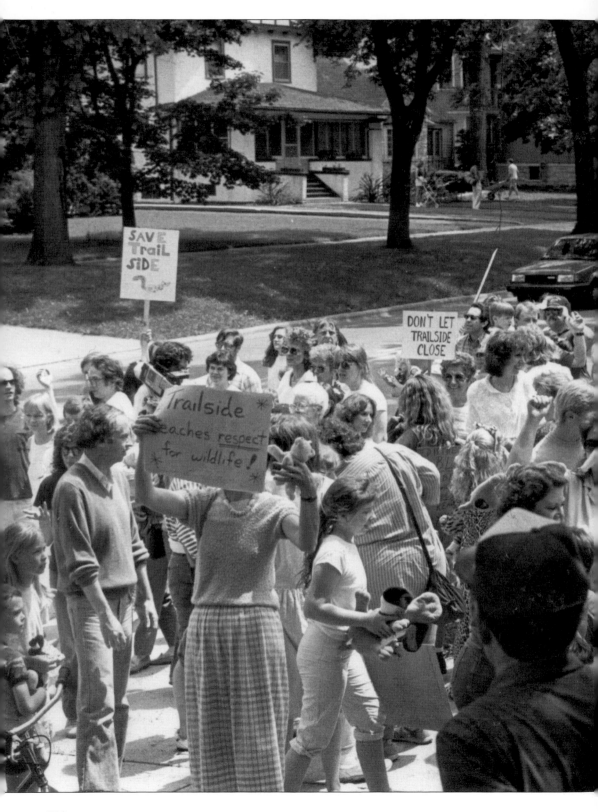

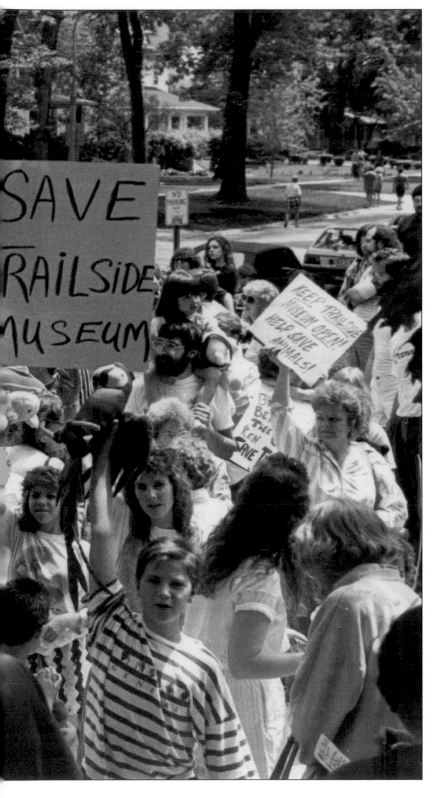

With hundreds of Trailside Museum supporters protesting the Forest Preserve District's closure of Trailside Museum, officials held a public hearing at their headquarters at Harlem Avenue and Lake Street in River Forest on June 27, 1989. John Grandy, vice president of the Humane Society of the United States, flew in from Washington, DC, to offer support from his organization. Nearly 30,000 signatures opposing the closure were presented by 50 members of the Coalition to save Trailside, while 100 more members cheered outside. Grandy proclaimed, "This turnout shows how much the community cares. The expertise of the staff is excellent. The question is whether the Forest Preserve District can give it the resources it needs to thrive." (Courtesy of Dawn Waldt.)

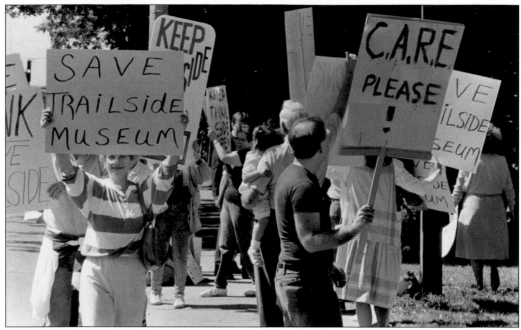

The Forest Preserve District Headquarters was the site of the very first protest march in 1989 to save Trailside Museum. Protesters carried "Save Trailside" signs and "Honk for Trailside," encouraging motorists on a very busy Harlem Avenue to support keeping Trailside open. (Courtesy of the *Wednesday Journal*.)

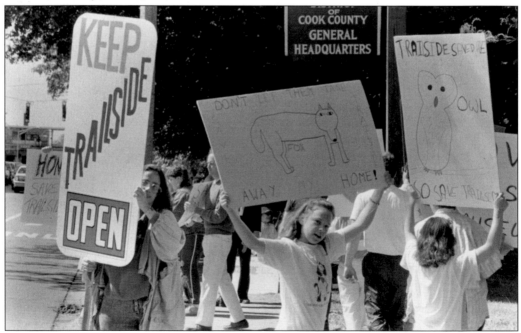

This 1989 image shows two young girls who were volunteer junior assistants holding up handmade protest signs as they march with other protesters in front of the Forest Preserve District General Headquarters in River Forest. The signs the girls made were their representations of real animals that received care at Trailside. (Courtesy of the *Wednesday Journal*.)

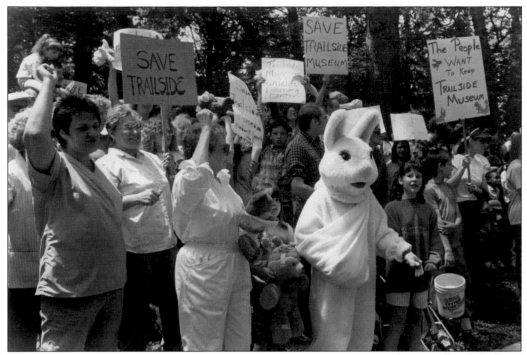

The impending shutdown of Trailside saddened many residents. Children from Lincoln School in River Forest and Hatch and Longfellow Schools in Oak Park began letter-writing campaigns to county board president George Dunne. In 1989, even longtime resident John Rabbit was represented by a person wearing one of Razzle Dazzle's donated costumes from their Oak Park store. (Courtesy of the *Wednesday Journal*.)

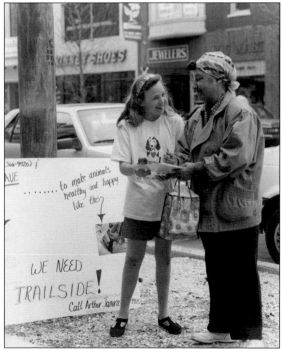

Downtown Oak Park in 1989 was one of many places where people signed petitions to keep Trailside open as a wildlife education and rehabilitation center. The sign to the left of the young girl encourages people to call the Forest Preserve general superintendent Arthur Janura to let him know how much Trailside is needed. (Courtesy of the *Wednesday Journal*.)

During all the hustle and bustle of 1989, residents tried to keep the county from closing down Trailside Museum, and Virginia Moe, now in her 80s, carried on her daily routines. Here, she is checking on the amphibians in one of the glass tanks as people view some of the other animal residents. (Courtesy of Dawn Waldt.)

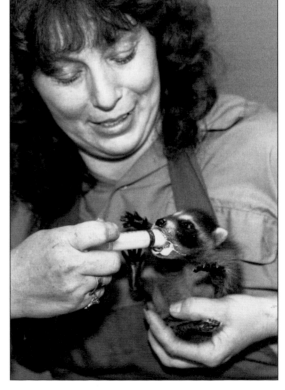

An infant raccoon (*Procyon lotor*), also known as a kit, eagerly takes formula from a dropper from deputy curator Diane Schulz in 1989. The raccoon's dexterous paws and distinctive mask are themes in the mythology of several Native American tribes. Schulz took over much of the rehabilitation responsibilities when Virginia Moe became ill after a fall in the front lobby of Trailside. Moe was hospitalized in Melrose Park, Illinois, at Westlake Hospital. Hospital officials said she appeared to be getting better, but she died on April 18, 1991. (Courtesy of the *Wednesday Journal*.)

Cook County commissioner Bobbie Steele smiles as she enters a River Forest home and is greeted by a raccoon costume character in 1990. Steele came out to attend a coffee meeting held for her in support of the grassroots efforts to Save Trailside Museum. (Courtesy of Dawn Waldt.)

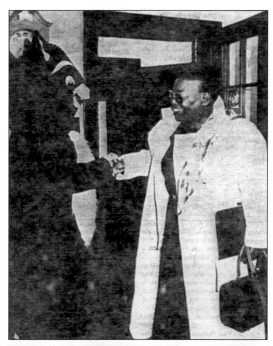

Tom Lagan and his daughter Kerry admire two American crows (*Corvus brachyrhynchos*) in one of Trailside's outdoor cages, likely around 1989. The crows would be released once it was determined they could make it on their own. Crows are considered to be among the worlds' most intelligent animals, and the collective name for a group of crows is a flock or a murder. (Courtesy of the *Wednesday Journal*.)

Three-year-old Claire McMahon, a River Forest resident, holds a young Virginia opossum (*Didelphis virginiana*) at the Trailside Museum in 1989. Claire visited the animals at Trailside with her mother during the summer of 1989. In a *Chicago Tribune* article dated June 2, 1989, Cook County commissioner Joseph Mathewson stated, "The Trailside Museum has provided exciting and educational experiences and fond memories of generations of Cook County Residents." (Courtesy of the *Wednesday Journal*.)

Six

Trailside Gets
a New Wing

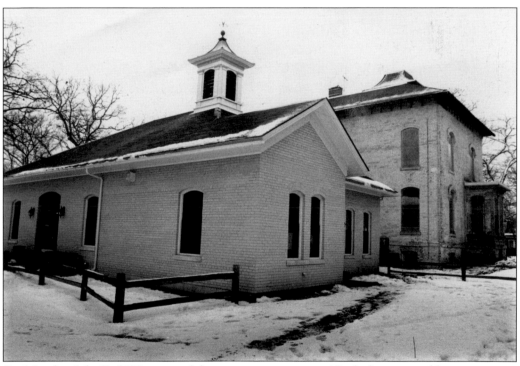

On Monday, July 31, 1989, as proof that a movement to save Trailside organized by a grassroots effort could really make a difference, the Cook County board of commissioners unanimously approved a recommendation to save Trailside Museum. Not only would Trailside be saved, but the county board also approved a recommendation to build an addition specifically dedicated to wildlife rehabilitation. The existing three-story building would be kept as an educational nature center. The recommendation also provided that the outside cages be added, pathways and overgrown vegetation be cleaned and maintained, and security fencing be added for the outside exhibits. (Courtesy of the *Wednesday Journal*.)

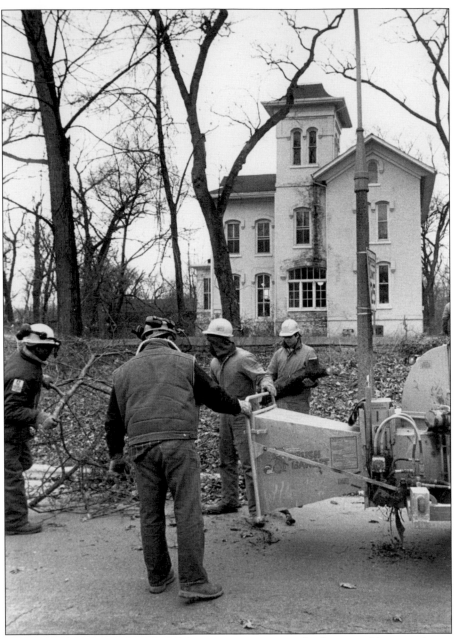

Workers clear brush in front of Trailside Museum in preparation for the new addition and renovation of the existing building. The brush clearing was done by the state of Illinois Youth Conservation Group from Kankakee State Park and the Forest Preserve Forestry Department in 1990. Also in 1990, a new superintendent of conservation, Chet Ryndak, took over for Raymond Schwarz. Ryndak previously worked at River Trail Nature Center in Northbrook, Illinois. Ryndak noted that the work at Trailside would get underway that year with initial construction starting on the first floor of the existing museum. He stated that construction of the new 2,000-square-foot addition would begin the next year, and Trailside would remain open during the new construction. Ryndak also stated that Trailside would be accepting fewer animals for rehabilitation during the construction. (Courtesy of the *Wednesday Journal.*)

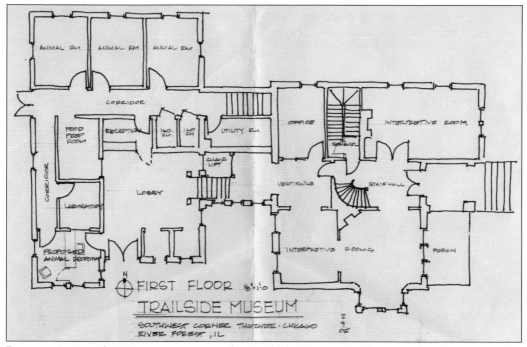

First floor plan labels: ANIMAL RM, ANIMAL RM, ANIMAL RM, CORRIDOR, FOOD PREP ROOM, RECEPTION, 160 RM., 160 RM, UTILITY RM, OFFICE, INTERPRETIVE ROOM, CORRIDOR, CHAIR LIFT, LOBBY, VESTIBULE, STAIR HALL, LABORATORY, PROPOSED ANIMAL DROP OFF, INTERPRETIVE ROOM CS, PORCH, FIRST FLOOR 1/8" = 1'0", TRAILSIDE MUSEUM, SOUTHWEST CORNER THATCHER · CHICAGO RIVER FOREST, IL, 2905

Between 1991 and 1994, renovations on the Trailside Museum's old structure and new wing for wildlife rehabilitation were completed. The addition was built first, and the animals were moved in. The new center included a kitchen, three rehabilitation rooms for animals recuperating from illnesses or injuries, a small bird room, a large bird room, a mammal room, two quarantine rooms, and a laboratory. All these additions were located in the newer rear building along with a public reception area. The old building held two large exhibit rooms and a multipurpose classroom. Several new outdoor cages were added to the south of the museum for animals that lived at Trailside permanently. Cages were added to the north of the museum away from the public so the animals could rehabilitate and get ready for release. (Above, author's collection; below, courtesy of the *Wednesday Journal*.)

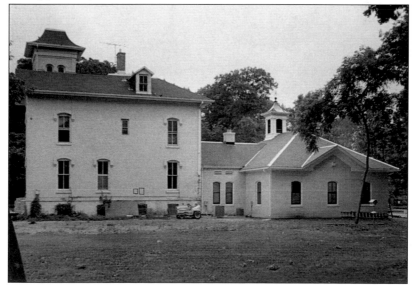

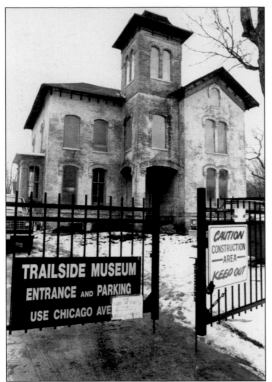

Renovations continue at Trailside Museum in 1993. Once the new addition was complete and the animals moved in, the old building also got a new look. The old yellow paint on the outside brick was removed, and new light fixtures and hardwood floors were added. Virginia Moe's old apartment on the second floor was also renovated and used for a time as an apartment for a forest preserve employee employed as a watchman for Thatcher Woods. (Courtesy of the *Wednesday Journal*.)

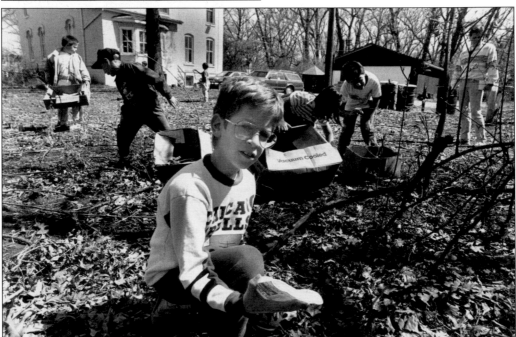

Matt Berry, a Cub Scout from Pack 364, picks up a paper cup in 1990. Berry and the rest of the boys from Pack 364 cleaned the area behind Trailside Museum. By 1990, Trailside Museum had been saved, and renovations on the old building and a new rehabilitation center would soon be added. (Courtesy of the *Wednesday Journal*.)

Cookie the Clown, from WGN's *Bozo Show*, whose real name was Roy Brown, appeared at Trailside Museum for a "Trailside Day" celebration. On May 23, 1990, Cookie holds five-year-old Catherine Silvers in front of Trailside Museum. To show his support for the museum's wildlife rehabilitation program, Cookie signed autographs and posed for photographs with children who came out to see him. (Courtesy of the *Wednesday Journal*.)

After the death of Virginia Moe in 1991, a new curator by the name of Sue Hall was appointed, shown here with Teenage Mutant Ninja Turtle Michelangelo. Sponsored by the Original Trailside Action Committee with the aid of the *Wednesday Journal* of Oak Park and River Forest, Michelangelo received the key to Trailside and was inducted into the Animal Hall of Fame. (Courtesy of the *Wednesday Journal*.)

Young and old alike came out for Trailside Day in 1990. The crowd enjoyed refreshments and signed up to get their copies of a reprinted version of *Animal Inn, The Stories of a Trailside Museum* written by Virginia Moe in 1946. (Courtesy of the *Wednesday Journal*.)

Bennie the Bull arrived at Trailside in 1990 to help launch the sale of *Animal Inn, The Stories of a Trailside Museum*, a reprint of the original version written by Virginia Moe in 1946. This version of her book was used as a fundraiser for the museum. National radio personality Paul Harvey wrote the preface. The raccoon costume was donated on a regular basis by an Oak Park costume shop called Razzle Dazzle. (Author's collection.)

In 1991, with proceeds from the sales of the reprinted version of *Animal Inn*, several cages were made for the museum birds and donated to Trailside. New director Susan Hall gave specifications for new cages to one of the grassroots groups responsible for helping save Trailside. Two members are pictured here in front of one of the new cages, Joseph Casale and author Jane Morocco. (Courtesy of Joseph Casale.)

Several members of the "Original Trailside Action Committee" are shown here in 1990 during one of their many fundraisers to help reprint Virginia Moe's *Animal Inn, The Stories of a Trailside Museum*. Pictured from left to right are (first row) unidentified, Anna Schnedorf, and Monica Affleck; (second row) unidentified, John Morocco, Jane Morocco, Liz Murray, and Dawn Waldt. (Author's collection.)

In 1992, the addition that was added to Trailside for wildlife rehabilitation was almost complete. Animals were moved into the lobby temporarily, and work had begun on the renovation of the old building. The stairway visible here led to a walkway to the old building, which would become the nature center. Next to the stairway, an elevator was also added. (Courtesy of the *Wednesday Journal*.)

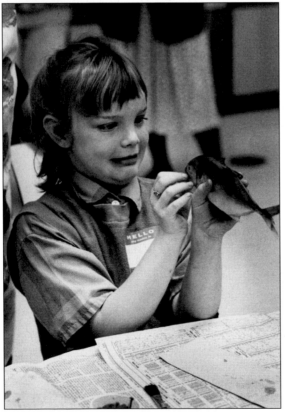

The back of this undated photograph says the image was used for a local school calendar. With a new wildlife rehabilitation addition built on to the existing building, children's classes were held in the old part of the Trailside Museum building, which was renovated with new wood floors and newly painted walls. (Courtesy of the *Wednesday Journal*.)

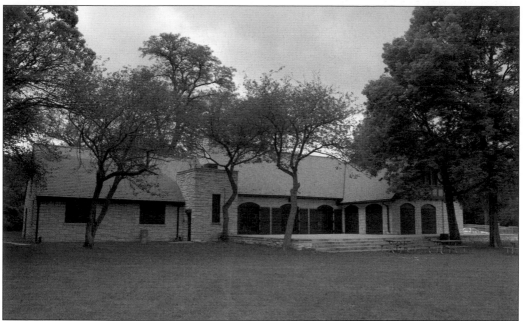

As of August 2014, the Thatcher Woods Pavilion is under construction. Lights are being added to the parking lot and around the building. A new parking lot is being installed and a patio will be upgraded with a fire pit. The interior of the building had air-conditioning, heat, restrooms, and a warming kitchen added some years ago. The building is handicapped accessible. The district's director of planning noted that they were going to improve the paths and add more signage for hikers. Films and other programs will be added once all the upgrades are completed as well as a new sidewalk for safer passage from the pavilion to Trailside Museum. Once all improvements are made, the Forest Preserve District wants to rent out the pavilion to the public for private events. (Both, courtesy of Michael Morocco.)

Pictured here are side and front views of the addition to Trailside Museum as it looked in August 2014. The addition no longer houses animals for wildlife rehabilitation. Several construction projects were ongoing as of this writing, and the museum was closed. According to the Cook County Forest Preserve District website, "The parking lot, walkways and interior will get a makeover. They are also installing a new accessible walkway and accessible seating in their outdoor nature play area." The museum offers public nature programs and guided hikes every month for children, families, and adults. School groups are welcome to make reservations to receive a customized tour with a naturalist. (Both, courtesy of Michael Morocco.)

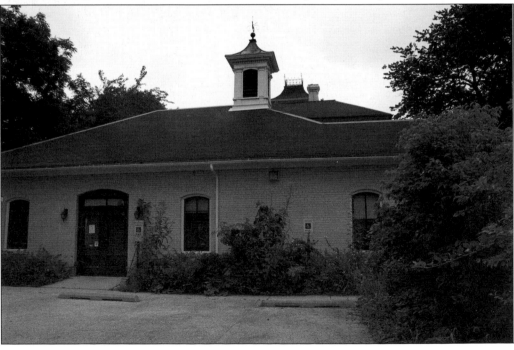

State representative Ted Leverenz was a big fan of Trailside Museum. As a staunch supporter, Leverenz attended numerous protests and fundraisers to save Trailside. Along with the efforts of senate president Philip Rock of Oak Park and state senator Greg Zito, in 1989, Ted Leverenz introduced a bill to allocate an additional $30,000 in state funding for new construction. (Courtesy of Ted E. Leverenz.)

The author is pictured holding the "Virginia Moe Way" sign. In 2011, the village of River Forest board president John Rigas, through the recommendation of Cook County board commissioner Peter Silvestri, suggested a street sign be dedicated in Virginia Moe's honor. Jane Morocco attended the board meeting and spoke on behalf of Virginia Moe. (Courtesy of Joe Casale.)

On March 21, 2011, the resolution honoring Virginia Moe by providing an honorary designation of the 700 block of Thatcher Avenue as "Virginia Moe Way" was adopted. The resolution stated, "Be it resolved by the President and Board of Trustees of the Village of River Forest, Cook County, Illinois, that the board, for its members and the citizens of the Village of River Forest, extend deepest and sincerest gratitude to Virginia Moe and adopt this resolution as a symbol of gratitude for the high quality of public service which she has rendered." The honorary street sign was placed directly in front of Trailside Museum by the village of River Forest. (Both, courtesy of Michael Morocco.)

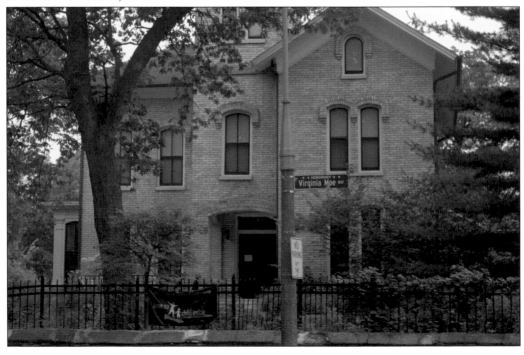

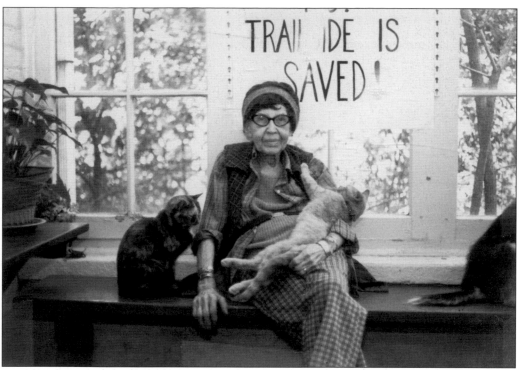

In this 1989 photograph, Virginia Moe smiles after hearing the news that the beloved museum she so faithfully served for over half a century would be saved. (Courtesy of Dawn Waldt.)

When the roll is called up yonder
"Ginny Moe" will fit into heaven with the least adjustment
of anyone I know.

And what a greeting awaits her from the countless
birds, animals and other dependent forest
creatures whom she has doctored and sheltered.

—Paul Harvey

BIBLIOGRAPHY

Alofsin, Anthony. *Frank Lloyd Wright. The Lost Years, 1910–1922*. Chicago, IL: University of Chicago Press, 1993.

Greenberg, Joel. *Of Prairie, Woods, & Water*. Chicago, IL: University of Chicago Press, 2008.

Hall, Albert. *History of River Forest*. River Forest, IL: Forest Publishing Company, Not Inc., 1937.

Hausman, Harriet. *Reflections: A History of River Forest*. River Forest, IL: self-published, 1975.

Johnson, Charles B. *Growth of Cook County, Volume 1*. Chicago, IL: Board of Commissioners of Cook County, IL, 1960.

Lamb, Ruth Mary. *Mary's Way, A Memoir of the Life of Mary Cooper Back*. Glenrock, WY: Future Prep Corporation, 1999.

Lockerman, Doris. *"His Politeness Turns Away a Lady's Wrath." Chicago Tribune*, October 11, 1937.

Mann, Roberts. *Origin of Names and Histories of Places*. River Forest, IL: Forest Preserve District of Cook County, IL, 1964–1965.

Moe, Virginia. *Animal Inn, The Stories of a Trailside Museum*. Boston, MA: Houghton Mifflin Company, 1946.

Pfeiffer, Bruce Brooks. *Frank Lloyd Wright: The Masterworks*. New York, NY: Rizzoli International Publications Inc., 1993.

Welter, Ardell. *"Animal Inn, by Virginia Moe." Gary Post Tribune*, January 21, 1947.

ABOUT THE VIRGINIA MOE SCHOLARSHIP

Proceeds from the author's royalties earned by this book are to benefit local schoolchildren in the form of a scholarship in the name of Trailside Museum's longtime curator Virginia Moe. Miss Moe dedicated her life to the community. She believed that in encouraging children to love and care for the wild creatures we share our planet with, those children would grow up to be caring adults, not just to animals, but to their families and communities. This scholarship will serve young people interested in pursuing a career in biology, botany, environmental studies, or wildlife rehabilitation.

Discover Thousands of Local History Books
Featuring Millions of Vintage Images

Arcadia Publishing, the leading local history publisher in the United States, is committed to making history accessible and meaningful through publishing books that celebrate and preserve the heritage of America's people and places.

Find more books like this at
www.arcadiapublishing.com

Search for your hometown history, your old stomping grounds, and even your favorite sports team.

Consistent with our mission to preserve history on a local level, this book was printed in South Carolina on American-made paper and manufactured entirely in the United States. Products carrying the accredited Forest Stewardship Council (FSC) label are printed on 100 percent FSC-certified paper.

MADE IN THE USA